Creating Letterforms

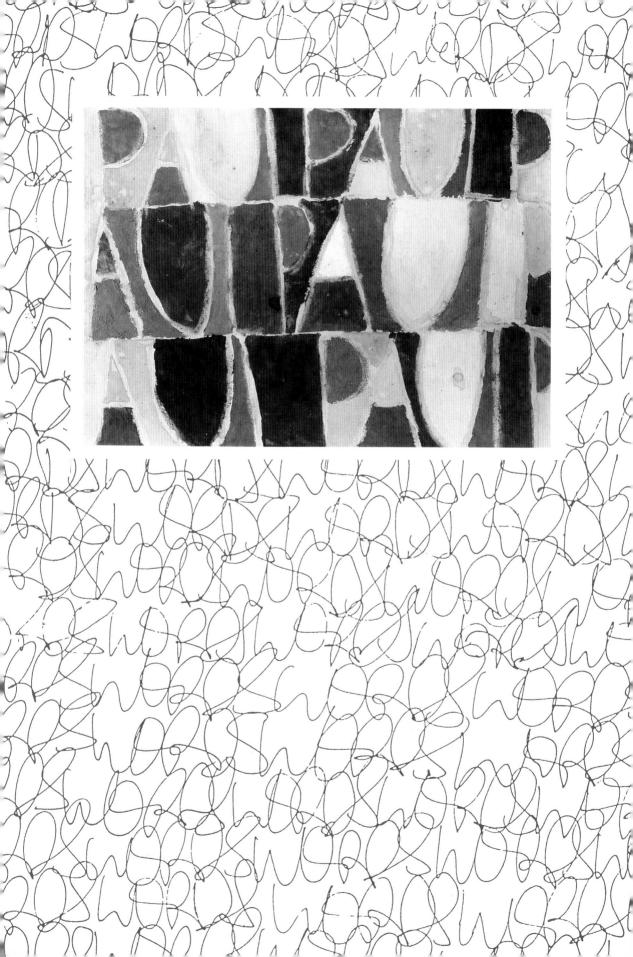

ROSEMARY SASSOON
PATRICIA LOVETT

Creating Letterforms

Calligraphy and Lettering for Beginners

with 188 illustrations

THAMES AND HUDSON

Frontispiece
A composition using the letters in the boy's name. Colour was added to highlight inter-letter space as well as that enclosed within some of the letters.

The main title on p. 3 and part titles on pp. 9 and 47 are set in Sassoon Primary, a typeface researched and designed by Rosemary Sassoon and drawn up by Adrian Williams. This typeface was specially developed to provide a bridge between reading and writing skills for children.

© 1992 Thames and Hudson Ltd, London

First published in the United States in 1992 by
Thames and Hudson Inc., 500 Fifth Avenue,
New York, New York 10110

Library of Congress Catalog Card No 91–66264

Printed and bound in Singapore

Contents

Acknowledgments

The illustrations in this book include examples of the work of many individuals, teachers and students alike, and we wish to thank them all for their contributions.

Peter Halliday and David Holgate have generously described their experiences in the interest of promoting the teaching of letterforms in schools and colleges. Maria Quiroz and Phil Baines have written about their projects that were part of the Craft Council's 'Spirit of the Letter' exhibition, and we are also grateful to Susie O'Reilly of the Craft Council who, during that exhibition and afterwards, has been so supportive of our work.

We also wish to thank those of our students who are not named individually, but whose enthusiasm and ideas have helped us to develop our teaching techniques over the years, and we must not forget the younger members of the Lovett family, Emma and Sophie, who have been willing guinea pigs and have produced quite a few examples of their own work for use as illustrations.

Particular thanks go to all those who have contributed to the second part of the book and whose work appears on the pages noted below:

Paul Green-Armytage and the students of the School of Design, Curtin University of Technology, Perth, Western Australia, pages 49–53, 55–63 and 96; Charles Creighton and some of his fellow-students from the summer school in Esperance, Western Australia, pages 50, 54, 57, 64 and 65; the staff and pupils of Amherst County Primary School, Kent, pages 47, 78–80, frontispiece and cover; Howard Macpherson and the pupils of Underdale School, Adelaide, South Australia, page 90; the staff and pupils of Mengham Middle School, Hayling Island, Hampshire, and Jackie Wadlow of Portsmouth Museum, pages 88 and 89; the students of St Vincent Sixth Form College, Gosport, Portsmouth, pages 91–93. Lynn Gash of the Castle Museum, Norwich, and John-Mark Zywko for his prize-winning 'Glue' illustrated on page 52; students at the John Taylor High School, Staffordshire, pages 82–87; students from the Department of Art and Design, Suffolk College, Ipswich, pages 94 and 95; Philippa Matthews, page 71.

Authors' Preface

THIS BOOK is intended primarily as a guide to the teaching of letterforms and can be used either by teachers or by students of any age. It is not a difficult task for a teacher to awaken young people's interest in letters that they encounter daily in every aspect of life. We show several different approaches, and stress the desirability of letting schoolchildren, in particular, choose their own route towards lettering skills. Some may wish to follow the traditional course of copying from a model, so for them several classic alphabets are illustrated (pp. 30–39). Students can choose which one they prefer to tackle first. For the more adventurous who want to branch out into developing their own letterforms, we have suggested many tempting ideas and techniques. Freely drawn letters, brush letters and letters designed with the aid of a computer are all part of the same story and are just as important as the traditional pen-lettering that the word 'calligraphy' suggests to most people.

The quality of the examples illustrated in this book, a number of them produced by children with no previous experience of lettering, suggests that an instinctive feeling for letterforms may be present in many individuals from an early age. Unfortunately, in recent times the study and enjoyment of lettering as a form of expression, or even as a necessary means of communication, has been very much neglected in schools and colleges. The advent of computerized type and other mechanical aids may soon produce a situation in which young people no longer feel the urge to understand or come to terms with hand-produced letters. Even seven-year-olds are becoming adept at making up a news-sheet with the use of computers, with letters appearing on a screen at the press of a button, yet adult students who choose to train as graphic designers all too often lack the visual perception and discrimination that can only be acquired through experience in 'handling' letterforms.

This book sets out to help remedy this situation. First Patricia Lovett explains ways of encouraging experiments with personal messages and ideas, and demonstrates simple but effective techniques that can be used by young children and adults alike. There follows an introduction to more formal penmanship, or calligraphy, taking students through the different classic models, with suggestions about how they should look and finally giving vital information for the carrying out and presentation of work.

Next, Rosemary Sassoon explores more deeply some of the many possible ways of approaching letterforms, designing them in different ways and with a variety of implements, including the computer. The age range is extended to include examples of art students' work, as well as that of younger students, still at school. The closing pages are concerned with the teaching of lettering in schools, including an outline of how to use the history of writing to stimulate young children's interest, and extending as far as calligraphy as an examination subject in the field of art and design. This discussion draws on the experience of several dedicated teachers who have achieved remarkable results, in some cases working with pupils suffering from physical handicaps or emotional problems.

A talented eleven-year-old will not learn to appreciate and enjoy calligraphy if made to practise mechanical repetition; in fact, the boy whose work is shown here clearly felt frustrated and could have been completely discouraged. However, when some of his best letters are extracted to form a word (reproduced actual size), it can be seen that he has produced some excellent letterforms. This process of selection helps young people to learn discrimination and gain self-confidence.

Discovering Letterforms

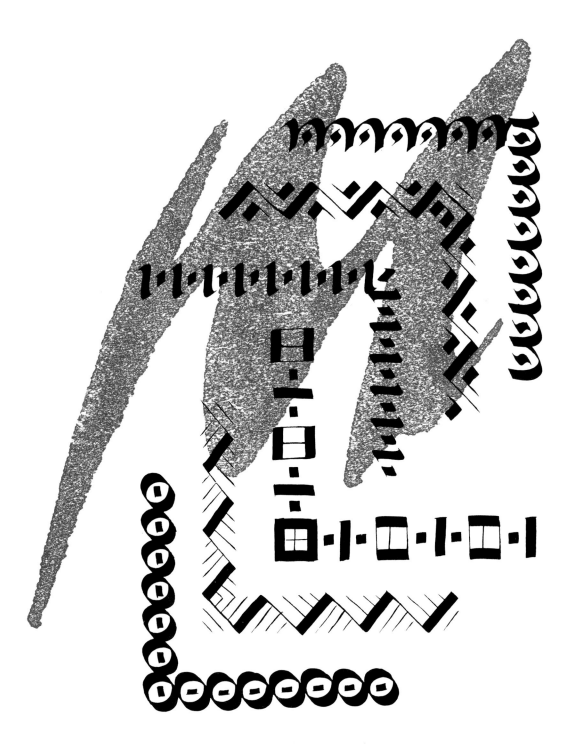

Capturing the imagination

Capturing children's imagination and seeing their delight in making their own letter shapes is a wonderful experience, and witnessing their excitement and enthusiasm as their knowledge of letterforms grows is even better. My experience of teaching children and adults has shown me that there is no one pen, ink, paint or even writing style which suits everybody. Some people find working with metal nibs and a rough-textured paper to their liking, others prefer quills and smooth vellum, and some are happy to use home-made felt pens and ordinary brown wrapping paper. Some find writing in an italic hand easier to master, perhaps because it is close to their own handwriting style, while others manage better with uncial or round hand. This variety of styles is what I have tried to show in the pages that follow. To begin with, there are many ideas and suggestions for different methods of making letters using a variety of writing materials and unusual pens; then, for those who wish to pursue calligraphy and look closer at letterforms, there are examples of alphabets written with a watery ink so that the construction of each letter is shown clearly; and, finally, ideas for practical uses of calligraphy.

Doing your own thing

Before you even start looking at letters in detail you can try to make your own ideas about letter shapes work in practice. Experimenting is fun. Emma, aged eleven, was trying her hand with a piece of balsa wood dipped in ink. When she produced an 'm' she liked, she used it in writing her name.

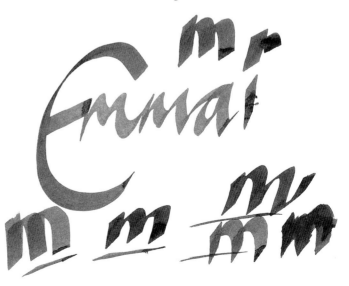

Seeing double

Using double pencils or pens is a good way to start calligraphy or lettering, as it shows the shapes of the letters clearly. Two pencils or pens are taped firmly together – masking tape or rubber bands are best for this.

Right-handers should tape two pencils together like this.

Left-handers should arrange their pencils like this.

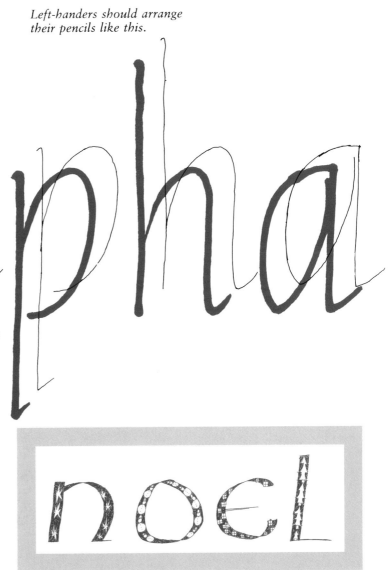

Combining a thick and thin pen or different coloured pens gives interesting effects.

After the outline is drawn, patterns and colour can be added as decoration.

Ten-year-old Sophie worked at these letters with two pens bound together with a strip of masking tape. When she was happy with the shapes, she drew Christmas patterns and made a greetings card.

Using scrap paper

Odd scraps of paper, with different textures and colours, can be used in two ways: either as a surface for your own lettering, as on this page, or as torn shapes, which can be combined with written letters or used on their own.

Strips of paper were rescued from the waste bin to make this card. The strips were stuck onto a darker card and a letter written on each piece.

A scrap of hand-made paper with an interesting torn edge made an unusual 'thank you' card. The surface of the paper was rough, so the letters are broken and uneven.

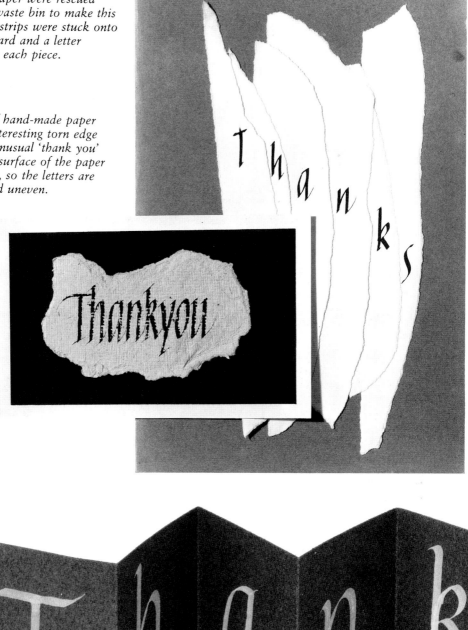

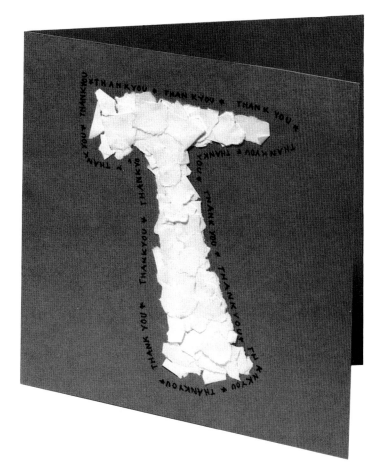

A ten-year-old girl decided to make good use of the paper she had torn into tiny pieces. A letter 'T' was drawn with stick glue on a card, and the scraps stuck on. Some of them fell off again and had to be stuck on individually to complete the shape she wanted.

Anna rescued a piece of photocopier paper, and decided to use it for a notice to go on her bedroom door. It was difficult to tear the letters out from the middle of the paper, so she used a clean paintbrush and water to 'paint' the letters on the paper. Once the water had soaked in, the softened paper tore easily. If the wet area is left for too long, the paper may need to be moistened again. Try this method whenever you want to tear a specific shape in a sheet of paper.

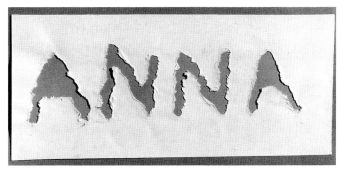

This strip of paper was cut off the bottom of a large piece of work. It seemed too good to throw away, and was folded to make a zig-zag 'thank you'.

Keep a box or large envelope to hold scrap paper which can be used for work like this.

Crumpled paper

Tissue paper, whether white or coloured, can be effectively used to make a background, a repeating pattern, or to create interesting letterforms.

Crumpled tissue paper, or a piece of kitchen roll, dipped in paint or ink, produces an unusual background pattern when stamped on a sheet of paper or card (the same method can be used to make an all-over pattern for a wrapping paper).

For this card a large paintbrush dipped in watery paint produced a wash which was then covered with clingfilm until almost dry. The message was written over the pattern after it was fully dry.

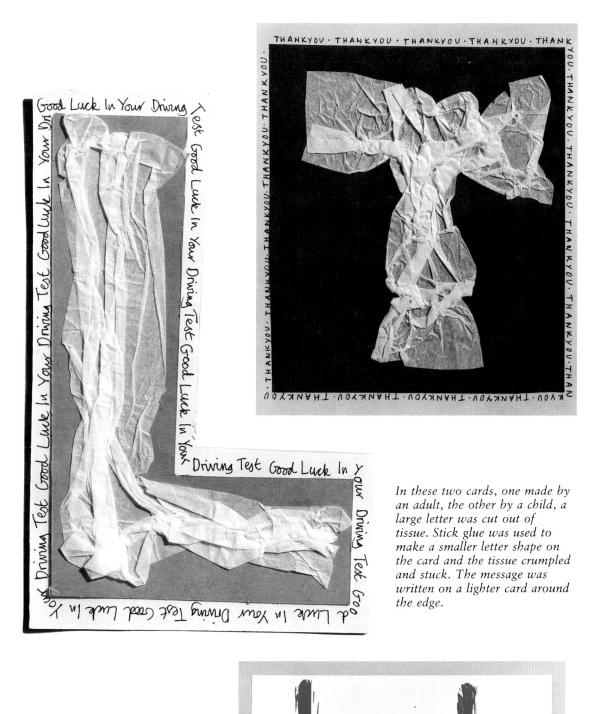

In these two cards, one made by an adult, the other by a child, a large letter was cut out of tissue. Stick glue was used to make a smaller letter shape on the card and the tissue crumpled and stuck. The message was written on a lighter card around the edge.

Tissue or a piece of kitchen roll can also be used for writing! Crumple it tightly and dip the end in ink – then write.

Cutting letters

Letterforms produced by using a knife and thin card or stiff paper have a characteristically sharp outline and can give interesting three-dimensional effects.

This card for 'DAD' was cut from a sheet of A4 card without drawing the letters first.

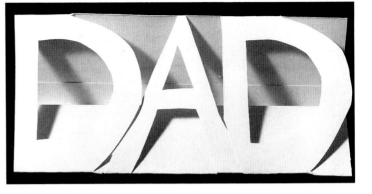

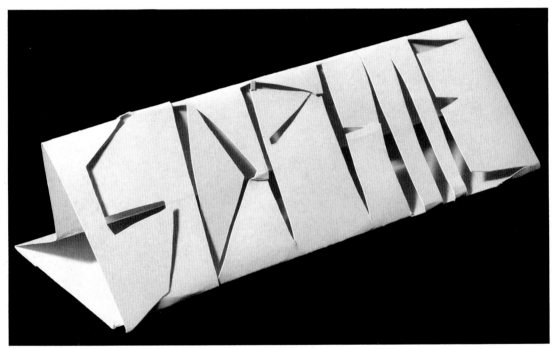

This greeting for Sophie made by a twelve-year-old was cut from an A4 card folded into three. The letters were cut out from one side, and the message written on another. The third side was folded in half, as shown, so that the card would fit into a standard-size envelope. An example of cut-out initials mounted on card of a contrasting colour is shown on the right.

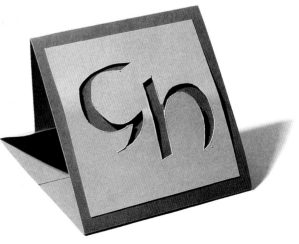

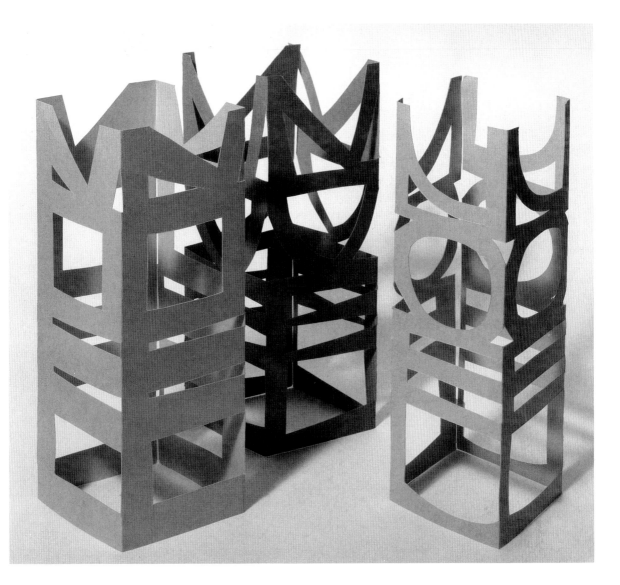

Red and green sheets of A4 card were cut with the word 'NOEL' repeated four times and then folded. The inside *shape of the letter is as important as the* shape of the letter itself. In each of these three examples the letter 'O' is different, and this affects the character of the whole word. After the edges were stuck together, the decorations were hung from the tree at Christmas.

Embossed letters

A knife can also be used when making embossed letters, raised above the surface of the paper, as well as incised or indented letters, which are sunk into the surface. Typing or copying paper works best, but cartridge paper or even thin card can be used.

First make a design. Double pencils were used in this example.

Thicken the 'thins' on the letters to make them easier to cut out.

Trace the design onto the card, making sure it is reversed.

Carefully cut out the letters from the card using a sharp craft knife and set them aside (they can be used to make incised or indented letters, remembering of course to reverse them). Stick this card onto a piece of card which is in a contrasting colour, positioning the insides of the letters (or counters) carefully.

Emboss the letters onto the back of the paper (so that any slips or mistakes do not show), using the end of a paintbrush, a modelling tool, the corner of a plastic ruler, a metal spoon handle or an agate burnisher.

Cut-out letters can also be used to make letter rubbings. Here the letter should be the right way round.

The cut-out letter

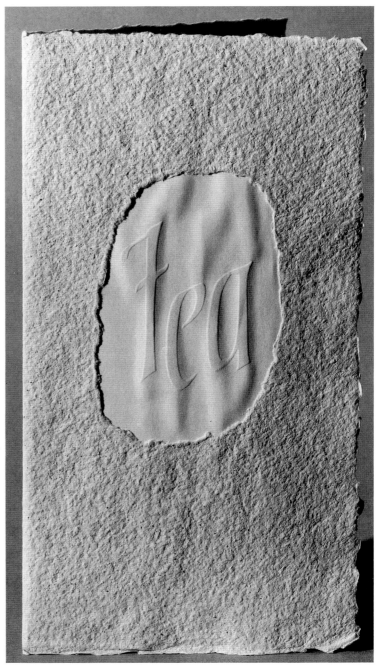

For this book-cover the letters were embossed into paper which was placed in a shape torn out of the cover. The endpapers were embossed with the same design used as an all-over pattern.

An embossed monogram designed and made by a thirteen-year-old for use as a letterhead.

19

Resists

Resists protect the surface of the paper from ink or paint and are effective, when you use white or light-coloured paper, as a method of producing white or light-coloured lettering for posters or other display material. Here are three possible ways of using resists:

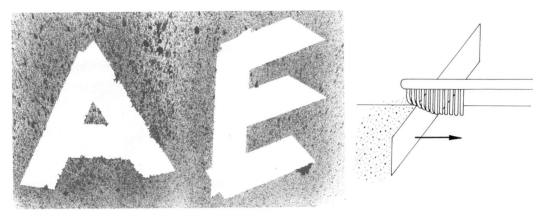

Masking tape. Simple letter shapes can be constructed by applying strips of adhesive masking tape to a sheet of paper or card. Paint or ink is then sponged around the letters and allowed to dry before the tape is peeled off; *or* a crumpled tissue or piece of kitchen roll dipped in ink or paint makes an interesting pattern; *or* a stiff stencil brush and dry-ish paint can be used; *or* an old toothbrush can be dipped in ink, shaken to remove the excess, then used to produce a spray by moving a ruler or finger in the direction shown above (otherwise it is VERY messy!)

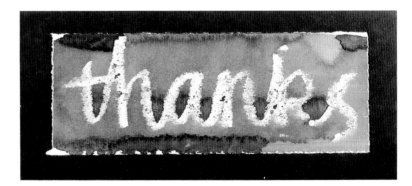

Wax candle. These letters were written using an ordinary household candle. The pointed end was cut off, and then a wedge was cut to make a good shape suitable for writing. After the letters were written, watery paint was applied with a wide soft brush, but any of the methods mentioned above could be used.

Before the masking fluid has been removed.

Masking fluid. This is a rubbery solution sold in art shops and some stationers. It is sticky and easily ruins good brushes, so handle it with care. These letters were written with a bamboo pen. After writing your letters, let the masking fluid dry and then cover it with paint or ink using any method you choose. When that is dry, remove the masking fluid carefully by rubbing it with a finger or a soft eraser.

Letters made up of straight lines only.

Stencils and lino cuts

Using stencils or lino allows you to repeat the same letters as often as you like. Thick card is essential for making stencils (the sides of strong cardboard boxes can be useful), but cutting out rounded letter forms may be difficult. Try instead to make an alphabet using only straight lines. When cutting out, always remember to work on a cutting mat or layers of cardboard.

These letters, based on initials of the 13th and 14th centuries, were cut out of lino, and could be used as monograms or letterheadings.

Rubber stamps

Using a set of rubber stamps is a simple and effective way of printing letters and shapes in various combinations and colours. You can use ordinary soft pencil erasers to make your own rubber stamps for any letter as shown here:

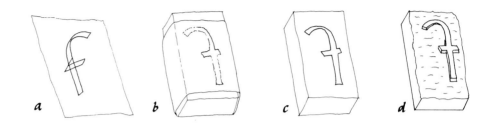

a *b* *c* *d*

(a) Draw the letter on tracing paper making sure that it fits within the surface area of the eraser. (b) Next transfer the tracing to the eraser, remembering to turn the drawing over so that the letter is seen in reverse. (c) Now cut round the outline using a sharp pointed craft knife with the blade held vertically. Cut quite deeply into the surface, but avoid going through the eraser or cutting under the letter. (d) When the outline is complete, carefully cut away the rest of the surface area, leaving enough of the eraser to allow a good grip.

To make a stamp pad, take a piece of folded kitchen paper towel or tissue and soak it in ink or paint. Two or more colours on the pad will give a mottled effect. If you do not produce a clear impression at first, it may be necessary to cut away more of the background.

As well as printing letters, you can also make patterns like the ones shown here made by an eleven-year-old girl who used nothing but an 'L'. In this way she could make flower shapes on the paper for wrapping a gift, as well as a personalized gift tag. Emma decided to make a penguin rubber stamp which she used on her stationery.

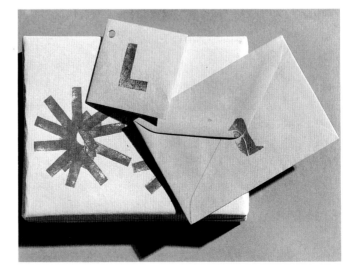

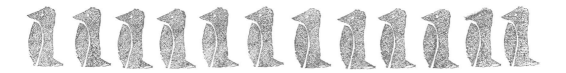

Emma also used her penguin stamp to make repeats and to produce decorative capital letters.

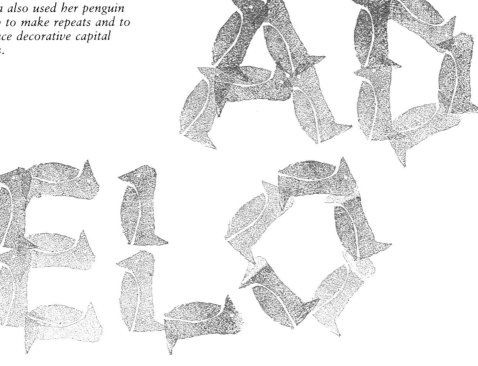

Having made rubber stamps of some basic shapes, it was interesting to discover how a complete alphabet could be created by combining or repeating a few shapes. A group of ten-year-olds discussed what shapes they would need: only a large circle, a small circle, a rectangle and a triangle were required.

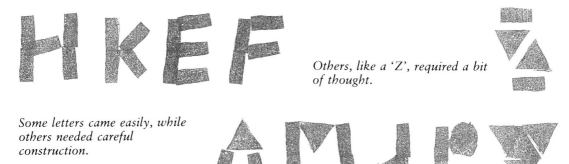

Others, like a 'Z', required a bit of thought.

Some letters came easily, while others needed careful construction.

Pens

Most people associate calligraphy with dip pens of one kind or another, but there are many other possibilities. They include ice-lolly (popsicle) sticks, twigs from the garden and a variety of easily obtained materials which can be cut in the right shape.

After being thoroughly washed, an ice-lolly (popsicle) stick can be used as a writing tool once a cut has been made across one end and then bevelled, using a sharp craft knife. The 'pen' is then dipped in watery paint or ink.

Balsa wood makes a good pen if one end is cut to form a wedge shape.

Polystyrene foam can be used to make pens which will form large letters on posters. Take a sharp craft knife and cut a block of foam using a sawing action, then cut a wedge shape at one end. This will be used as the nib. In order to produce sharp letters with clean outlines, cut a narrow slice straight through the nib tip.

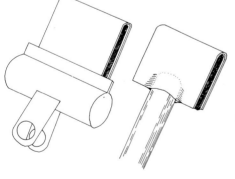

Home-made felt pens can give interesting results. Wrap a piece of soft craft felt around a small rectangle cut from a piece of balsa wood. This can be held in place by a strong clip or by being attached to a wooden handle or a length of wooden dowel.

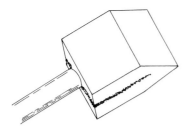

Foam rubber is another material which soaks up ink readily. Try to get foam which is densely packed with not too many holes. This can be cut into a wedge shape if it is fairly stiff, or, if it is a little soft, a strip can be bent over on itself, stuck together with a glue suitable for foam rubber. When the glue has dried, the bend can be trimmed to make a wedge shape. The foam can be fixed to a handle like a pen-holder to make it more comfortable to use.

To cut a bamboo pen:

1. At the end away from a joint make a long diagonal cut with a strong craft knife.
2. Scrape out the pith.
3. Put the bamboo with the diagonal cut downwards onto a flat surface, such as a cutting mat or layers of old cardboard, and make another, much smaller angled cut to bevel the top of the 'nib'.
4. Trim the sides of the tip to the required width of nib.
5. Again on a flat surface, with the bevel side upwards, make one or two slits, about 1–1.5 cm ($\frac{1}{2}$–$\frac{3}{4}$ in.) long. This allows the ink to flow. The number of slits depends on how wide the tip has been cut — wider nibs need an extra slit.
6. Lastly, turn the pen over and make a thin slice straight through the nib.

The pen will need to soak up a lot of ink before it writes evenly, so choose a watery ink or paint.

A similar cutting technique is used for quills and reed pens.

Sticks and twigs from woods or gardens, or the dried stems of plants can be broken or torn to make pens which will produce interesting effects.

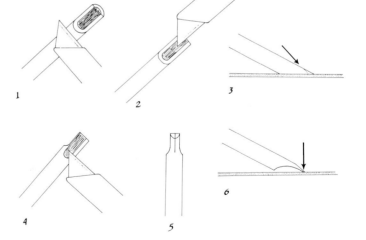

Bamboo pens have been in use for centuries. Thin bamboo canes (as used in the garden) cut into short lengths, about 25–30 cm (10–12 in.) long, make good pens It may take a bit of practice to cut a good bamboo pen, but the effort is worthwhile. Plastic tubing can be cut and used in the same way.

Pens, ink ...

There are several types of broad-nib pen available, all suitable for calligraphy. Of these the calligraphy felt tip is probably the easiest to use, but the letters produced are not always sharp and crisp and the pen cannot be refilled for repeated use. Felt-tip pens come in several colours, but have a limited range of tip widths.

Calligraphy felt tip

A calligraphy fountain pen will usually give a sharper result. It can be refilled and will take coloured fountain-pen inks, but there are not many nib widths available.

Calligraphy fountain pen

Square-cut nibs are used by right-handers.

Left oblique nibs are for left-handers.

The best results come from using the traditional 'dip' pen and a variety of different nib widths. The steel nibs will fit most pen-holders and can be obtained wherever artists' materials are sold. They are used with a reservoir fitted under the nib to retain the ink which is applied to the nib with a brush. If the pen is dipped into ink, the result may not be crisp because the ink may flood out of the pen. Dip pens usually come with packs of ten nibs, together with reservoirs and a pen-holder. Beginners may find it easier to start with the broader nibs.

Fountain-pen ink is usually too watery to use with a dip pen, although it is obviously the most suitable for calligraphy fountain pens. For a dip pen non-waterproof inks are best, and a variety of these can be purchased. Waterproof inks contain some shellac, which hardens and then clogs the nib, and these should not be used.

For colour work try using gouache, which is opaque watercolour diluted with water to a consistency which writes evenly. If gouache is mixed too thinly, the resulting letters will look watery; if too thick, it will not flow easily. Gouache should not be used in fountain pens.

Nibs, reservoirs and brushes should always be thoroughly washed and dried after use.

and paper

Almost any paper can be used for calligraphy. Many of the examples shown in this section of the book were done on ordinary photocopying paper or paper from a writing pad. For practising big letters, planning work or when working with rubber stamps, stencils or linocuts, a long roll of plain lining paper (wallpaper) is economical because any suitable length can be cut as desired. For finer work, pads of layout paper are a good buy, especially as it is partly transparent. This paper can be placed over the best letters on a trial version and a tracing made. Some calligraphers have even used brown wrapping paper. Cartridge paper provides a good surface and some watercolour papers are suitable for calligraphers, but check the surface first.

The texture *of the paper affects how the letters look.*

Smooth paper — paper passed through hot rollers in the manufacturing process, also called 'hot press' *or* 'HP'.

a b c

Paper with some texture — paper not *put through hot rollers and so called* 'Not'.

a b c

Rough paper — paper with a very uneven texture (sometimes quite hairy) called 'Rough'.

a b c

Setting out

Most calligraphers use a sloping board as a work surface. The angled surface provides a more natural writing position for the hand and allows better control of the ink. There is no need to buy an expensive drawing board; a piece of wooden board hinged to another or propped up on books, or even a large tray, is all that is needed. Most people find it best to set up their board at an angle of 45°.

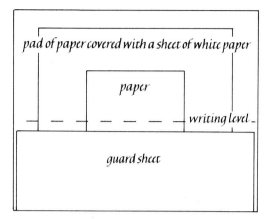

For left-handers the board can either be set up as for right-handers (above left), the writer's hand being twisted to the left to maintain the correct angle, or the sheet of paper can be turned at an angle of about 25°, as shown (above right).

A couple of sheets of white blotting paper or a few sheets of newspaper covered with white paper and attached to the board make the surface more comfortable for writing. A large piece of paper (cut from a roll of lining paper possibly) folded and taped across the board as a guard sheet not only protects the writing paper from any dirt or grease on the hand, but also means that the sheet of writing paper can be moved up and down behind it. The writing paper is not pinned or attached to the work surface, but is adjusted so that the writer's hand is always at the same comfortable level.

A quick and easy way of showing even spacing for each line is to make two pencil marks for the x-height on a piece of paper and use this as a guide as you work down the sheet.

A pair of dividers can also be used to prick out your chosen line spacing.

The height of the letters, known as the x-height (or the height of the small letter 'x'), is measured in nib widths. The number of nib widths affects the appearance of the letters, as seen in the examples using 3, 5 and 7 widths. The correct number of nib widths is shown with each of the alphabets illustrated on the following pages.

Notice how the character of the letters – particularly the shape within – is altered when the angle of the pen is changed. The pen nib needs to be correctly positioned, and the angles suitable for different styles of alphabet are shown on the following pages.

spaceꞎbetweenꞎwords

Spacing

The spacing between words looks best if a gap is left about the same as the space occupied by the letter 'o' in that alphabet.

minimum

The spacing between letters should look even. Spaces between letters should look about the same as the spaces within letters. This is easy to see with the word 'minimum'.

Pen patterns

Making patterns with a broad nib provides good practice in keeping the pen at the same angle and achieving consistent results.

Drawing simple repetitive patterns like these is a useful introduction to the basic strokes used in the alphabets shown in the following pages. Such patterns can also be used to form decorative borders around a piece of work. To ensure that the results are regular and even for a border, draw the patterns between two parallel lines and measure the distances for each section of the pattern.

29

FIVE CLASSIC ALPHABETS

The five alphabets that are illustrated on the following pages are adapted from historic hands originally developed from Roman times to the Renaissance in the 16th century. Although each hand is related to its historical period, the examples shown provide models which can be used today either to give a 'period' feel to writing or in other more experimental ways.

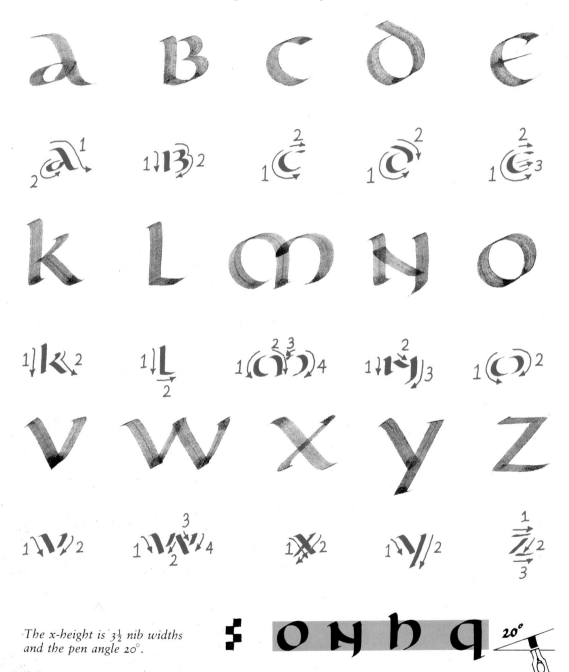

The x-height is 3½ nib widths and the pen angle 20°.

30

Uncials

Uncials were used by scribes from about AD 400 to 700 and can be seen in the manuscripts of this period such as the St Cuthbert (Stonyhurst) Gospel. The best order for pen strokes is shown for each letter of the alphabet.

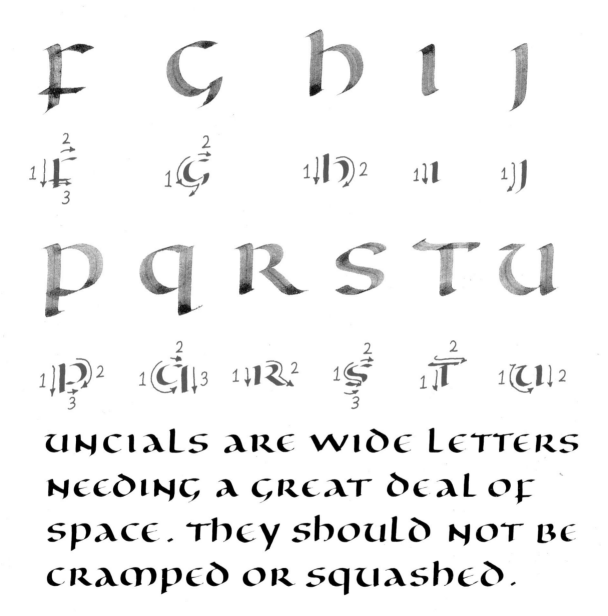

UNCIALS ARE WIDE LETTERS NEEDING A GREAT DEAL OF SPACE. THEY SHOULD NOT BE CRAMPED OR SQUASHED.

Because there are no capital letters, initial letters can be written slightly larger, possibly with a wider nib, or emphasized with a change of colour.

Versals

Versals are elegant capital letters which can be used for headings or as initials. They are based on Roman incised letters and are built up with several pen strokes and two different pen angles to produce the thicks and thins. Although left-handers may have difficulties with other alphabets, versals are as easy for them as they are for right-handers.

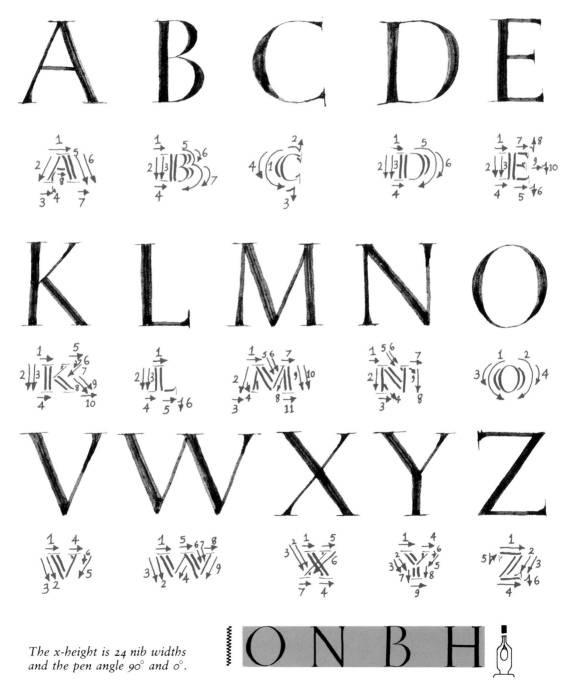

The x-height is 24 nib widths and the pen angle 90° and 0°.

HEADING

The oval shape of the letter 'O' gives the pattern for C, D, G and Q.

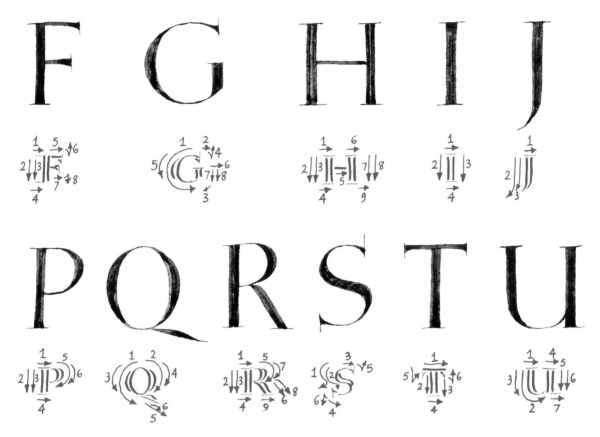

Versals look effective when used as the initial letter at the beginning of a sentence.

They should be larger than the accompanying writing and set a little apart from it.

Versals lend themselves to decorative use and to inclusion of a second colour.

Round hand

Round hand is one of the most elegant styles of writing. A striking example of its use can be seen in the Winchester Bible, written during the 10th century (and now on display at Winchester Cathedral). The style was adapted by the eminent calligrapher Edward Johnston (1872–1944) to form his 'Foundational Hand', and the methods used in forming these letters can be applied to many other hands.

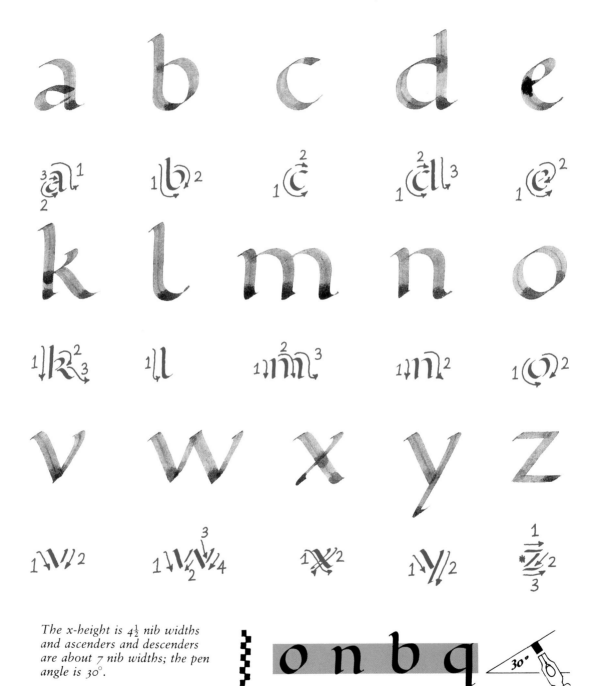

The x-height is $4\frac{1}{2}$ nib widths and ascenders and descenders are about 7 nib widths; the pen angle is $30°$.

ABCDEFGHIJKLM
NOPQRSTUVWXYZ

Capital letters are very slightly lower than the ascenders at 7 nib widths.

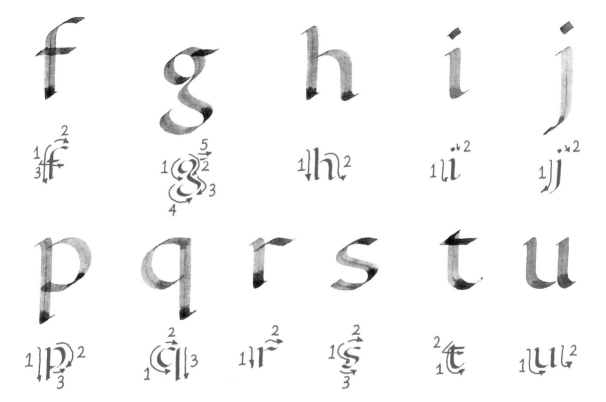

Calligraphy in round hand looks formal and important. It can be used for poems, prose, certificates and presentation scrolls and panels.

✳

Flatten the nib angle for this stroke to avoid a thin line.

Round hand is based on a round letter 'o' which provides the pattern for all related letters.

Black letter

Black letter was in use for books and documents from the 12th to the 15th centuries. It was adapted by the German printer Johann Gutenberg *c.* 1450 for the first movable type. A solid page of black letter gives the effect of a dense textured pattern and can be difficult to read. Before starting to write in this style, it may help to draw some vertical parallel guide lines.

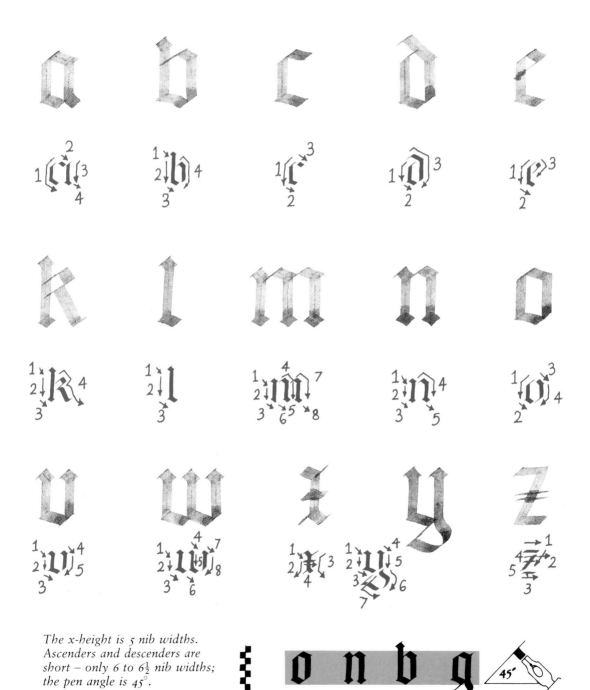

The x-height is 5 nib widths. Ascenders and descenders are short – only 6 to 6½ nib widths; the pen angle is 45°.

ABCDEFGHIJKLM NOPQRSTUVWXYZ

Capital letters are 7 nib widths high and very elaborate. They are best kept as initials.

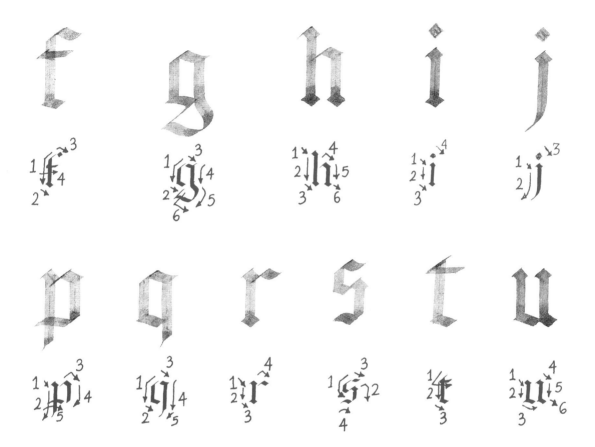

It is important with this hand that the spaces within and between the letters are kept regular and even. Try also to keep the lines the same length.

Italic

Italic is the name given to the style developed during the Renaissance. The sloping letters are written at an angle of 5° to 7° from the vertical. It may help to draw parallel guide lines at this angle. The letter 'O' is oval and provides the pattern for all related letters.

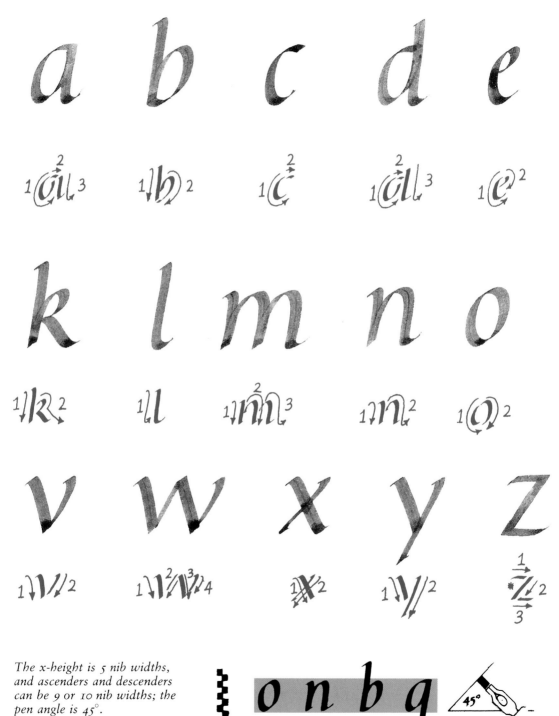

The x-height is 5 nib widths, and ascenders and descenders can be 9 or 10 nib widths; the pen angle is 45°.

A B C D E F G H I J K L M N O P Q R S T U V W X Y Z

The height of capital letters is 7 nib widths.

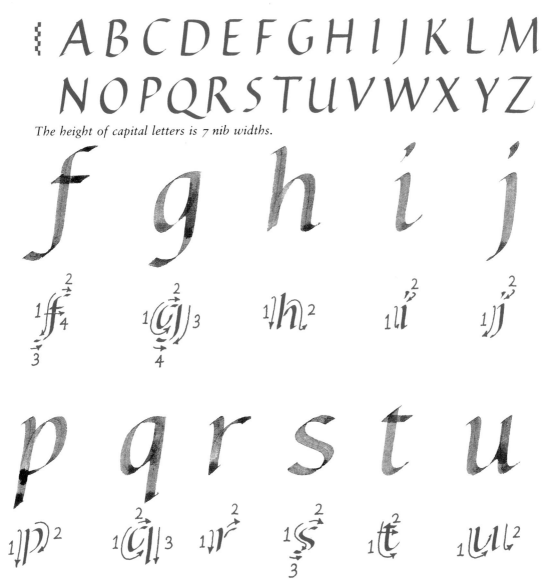

The italic hand is a flowing style of writing which has curves and not angles. Remember to keep the letters even and not jerky or pointed.

Flatten the nib angle for this stroke to avoid a thin line.

When writing italics, it is sometimes better to keep the pen nib on the paper, making fewer lifts than is usual with other styles of writing, in order to maintain a good flow.

Layout

Various ways of setting out a text: aligned on the left margin; in two columns; aligned on the right; and with each line centred.

When a text is to be written out, both style and layout are affected by its content, whether verse or prose, and this will also help to decide whether the result should appear formal or informal and how the text should be positioned on the page. Start by writing a rough version. The simplest method of setting out is to start each line at the left-hand margin, following the natural length of each line in the case of a poem or carefully choosing a suitable line break when writing a piece of prose, but lines can also be arranged in two columns (in the case of a longer piece perhaps) or end at the right-hand margin. They can also be centred. For these last two styles it is best to cut up your rough version to make each line into a strip and then position them all carefully according to your layout. For a centred layout each strip can then be folded to find the middle and positioned over a faint pencil line drawn down the centre of the sheet. The rough draft of each line can be placed immediately above the space where it will be written in its finished form and held in place by small pieces of masking tape; in this way spelling and spacing errors are more easily avoided.

Presented to

Barbara Joanne Crawford

on the occasion of her retirement

on the occasion of

In this example guide lines were drawn in pencil to help maintain a consistent slope.

Before deciding on a final layout, write out your text in rough form and try placing it in various positions on the page to judge the most effective presentation.

How to draw a spiral as a guide

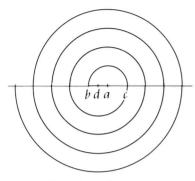

You will need a ruler, a pencil and compasses to draw a series of semicircles as shown in the diagram.

1. *On the paper or card to be used for your piece draw a faint horizontal line and mark on it point a at the approximate centre of the design.*
2. *Decide on the radius for your first semicircle and, placing the point of the compasses at a, draw a semicircle above the horizontal line from point b to point c.*
3. *Now mark point d between a and b and, with d as centre, open the compasses further to radius d–c and draw a semicircle below the horizontal from point c.*

A few experiments may be necessary to help you decide on the best distance between points a and d to suit your spiral design.

4. *To extend the spiral continue the same procedure, alternating centre points a and d and increasing the radius for each new semicircle.*

After the chosen text has been completed in ink, the pencil guide lines can be erased.

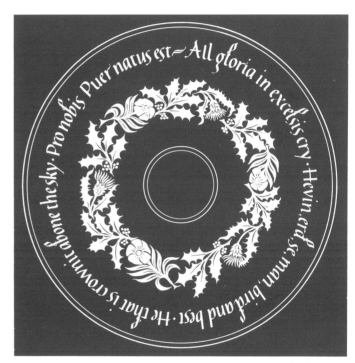

Writing in the round or in a spiral is a more ambitious kind of presentation which can be a very effective way of setting out a short text. After every few letters you need to rotate the work a little in order to keep a steady angle. The decorated Christmas card illustrated here was laid out using a series of concentric circles as guide lines. The design includes words by the Scottish poet William Dunbar, and the Scottish flavour is emphasized by the addition of thistles to the traditional decoration of holly and Christmas roses. For this kind of layout careful planning to fit the text evenly within the circle is necessary.

Making greetings cards and invitations

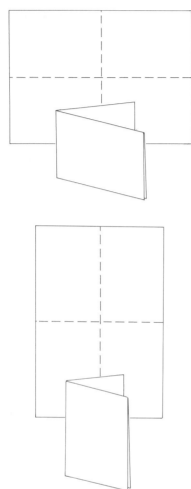

Folding a sheet of paper horizontally or vertically affects the shape of the card.

When making your own cards, perhaps the most important point to consider at the outset is the size of the envelope. It is far better to produce a card to fit a standard-size envelope than to spend time making a beautiful card which then needs a special hand-made envelope, especially as the envelope will probably be thrown away immediately! An A4 sheet can be folded twice to fit a stock envelope, and can be used upright or lengthwise, as shown here.

Make sure that the folds are at the left-hand side and top of the card. The message inside can be written and decoration added on what will be the outside of the card before the sheet is folded. Using a photocopier is a reasonably cheap and easy way of producing a number of uniform cards. Prepare the original in a good black ink or black gouache on white paper. It is worthwhile taking time to produce a good original. If necessary, it is also possible to 'white-out' any errors or smudges and to stick on any corrections which will not be picked up by the photocopier. Use process white or opaque bleedproof white mixed with a little water and applied with a paintbrush for corrections. Commercial correcting fluid also covers errors and smudges, but the applicators are more difficult to use with precision, and since such products are spirit-based it is unwise to apply them with good brushes. Before making copies make sure the photocopier screen is clean. Any marks on the glass will be reproduced, so spoiling the appearance of the card. The design can be photocopied onto suitable paper or card of any colour.

When using a photocopier for multiple printing, economical use of the machine is important. Try to design the card so that each sheet has to go through the machine only once. A zigzag card, for example, needs to be printed on one side only, before the sheet is folded.

To add a personal touch you could add a gold star or gold dots to Christmas cards, or introduce a contrasting colour with the aid of a rubber stamp or stencil.

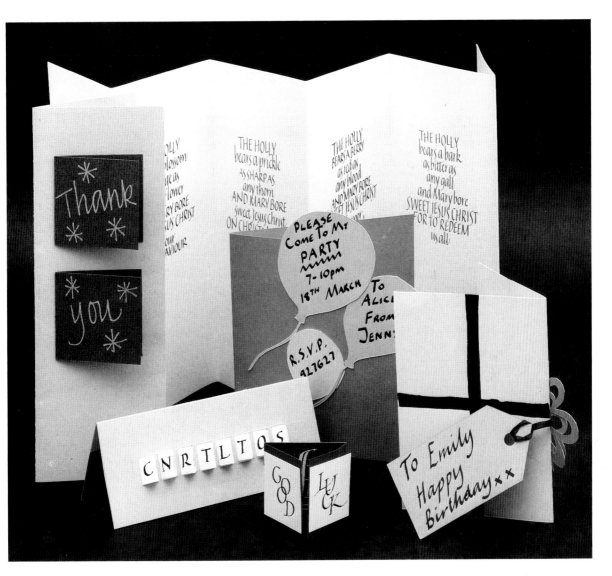

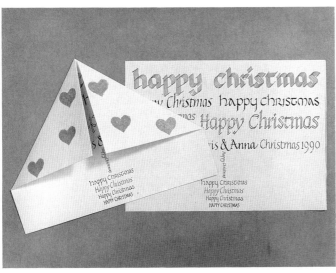

A selection of hand-made greetings cards. The narrow one on the left was made by slotting a strip of paper through slits in the card; the full message reads 'CONGRATULATIONS'.

After the basic design had been photocopied, this card was decorated with hearts made with a rubber stamp and folded over.

Manuscript books

Moisten the edges of a piece of paper, about 5 cm (2 in.) from the corner. After a few seconds it will begin to curl up or cockle in the grain direction.

A hand-written book is a pleasure to make and to receive. It can contain favourite quotations, verse or prose, and can be decorated with drawings and paintings or with rubber stamps and embossing. Choose a fairly lightweight paper, testing its suitability by folding a sheet in half and holding it along the fold. It should bend over gently and not be too rigid or too limp. If both sides of the paper are to be used, write on both sides of a test piece to check the amount of show-through. If the result is not satisfactory, choose a more opaque paper. When using manufactured paper, it is essential to check that the *grain direction* runs from top to bottom of the pages. This will ensure that they lie flat when the book is closed. In the case of hand-made paper the grain direction is irrelevant.

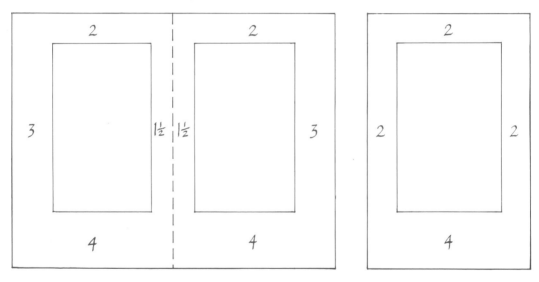

The proportions of the margins (shown in units of length) will vary depending on whether the text appears on a double spread or a single page. The correct proportions are indicated in the diagrams.

For a formal book it is best to follow the traditional margins for double spreads and single pages, the proportions being as shown in the diagram above, but it is always possible to be adventurous.

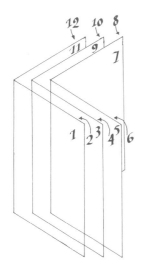

Plan the layout of your book by making a mock-up, with the pages numbered in pencil.

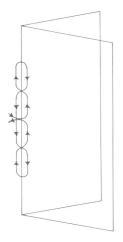

Embroidery cotton, thin ribbon or string or bookbinder's linen thread can be used for sewing the pages. Mark the mid-point on the spine of your book, then measure and mark four points, evenly spaced, with two above and two below the mid-point. Begin sewing from the outside if the knot or bow is to appear on the outside of the book. Begin sewing from the inside if the knot or bow is to be on the inside. After tying a knot, trim the thread to leave about 1 cm ($\frac{1}{2}$ in.), then fray the ends using the point of a sewing needle.

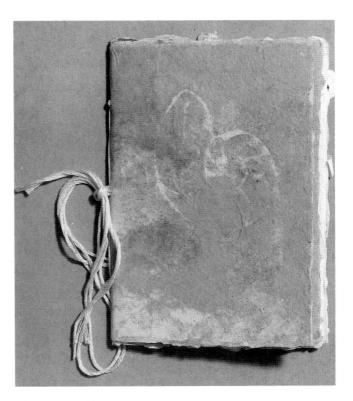

The cover offers even more scope for invention. This example by a nine-year-old uses decorated hand-made paper and is finished with a bow on the outside. The ingenious arrangement shown below involves a wrap-around cover secured with a feather.

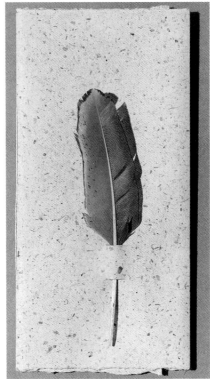

The diagram shows how this book was made.

Planning a lettering project

Sometimes an idea for a project will present few problems; on other occasions several preparatory stages may be necessary. A project of my own is illustrated here. I chose the Signs of the Zodiac as the theme because I liked the simplicity of a set of 15th-century woodcuts, on which my drawings were based.

The first stage was to sketch possible layouts, combining text and drawings. I decided that each Sign should be framed in a rectangle, and tried drawing straight lines with a ruling pen and uneven edges with a fine paintbrush. I then thought of presenting the Zodiac as a 12-page zigzag book, and decided that borders were unnecessary for this. I had to experiment with different papers to find the one best suited to the fine nib I had chosen, and I also decided to apply a watercolour wash – varying from blue in winter to warm red for summer months – behind the drawings. Variable amounts of space between drawings and text were also tried. This experimentation shows how a design idea can be developed and improved in stages.

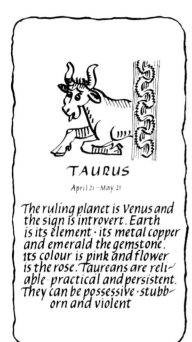

In an early version the lettering looks rather dense and there are some awkward word-breaks. The second version was improved by increasing the amount of space between the lines.

At the third stage colour was introduced as a background wash and to draw attention to the dates, and the headings were given more weight.

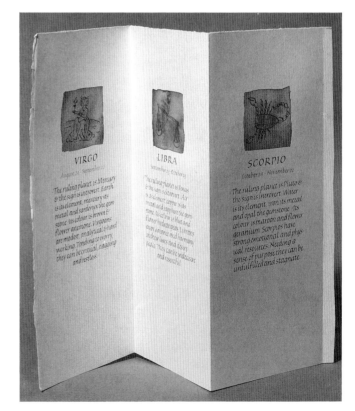

Learning About Letterforms

Introduction

IN ONE SENSE we all produce original letterforms, as seen in our everyday handwriting. Indeed, handwriting is as much an individual 'design' statement as any drawing or painting, and it is directly related to the way in which we wield the pen and use our bodies. If we want to carry this design process a stage further, it helps to have some idea of the kind of letters we would like to produce – a direct line from the mind's eye to the paper via the hand. If that idea does not already exist, you can make a start by enlarging and formalizing the letters that flow most easily because they are part of your personal 'hand'. Few of us like or value our everyday informal scribble, but once this is seen as a relaxed character script it is possible to select the most interesting letters and build on them to create a display alphabet – or even construct a design for a typeface, as shown on pp. 66–67. A broad-edged pen or some flexible writing implement such as a brush maximizes the effects produced by the unusual pressures and individual movements that often lie hidden in personal handwriting. However, the informal nature of personal letters should not be regarded as an easy option, for it is certainly no simple matter to produce a complete or consistent alphabet.

Among the many ways of discovering more about letters, examining the influence of different tools when producing letterforms can provide a good starting point. The more unorthodox the implement, the more original the resulting letters may turn out to be. A quick look at the characteristic features such as the terminals and weights of distinctive display typefaces can also inspire new ideas in the minds of those who may never have given such details a second thought before.

A collection of as many forms as possible, even of variations of one single letter, can show how wide is the historical repertoire and how extensive are the

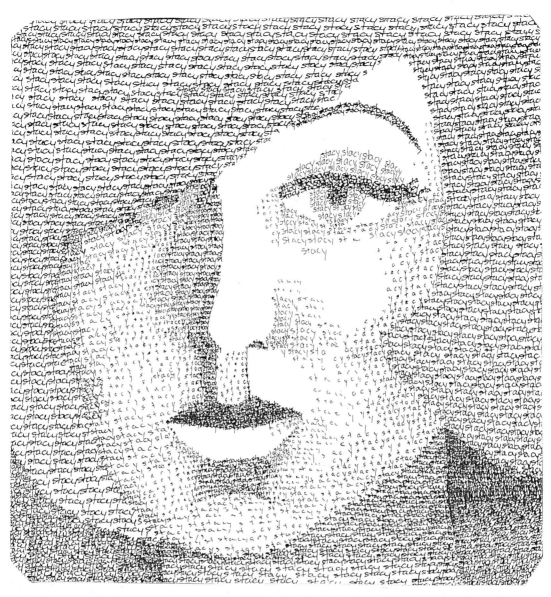

A self-portrait skilfully built up by Stacy Parker, using only her own name handwritten with varying density to convey shading.

possibilities for having fun with letters without them losing their individual identity. Ideally letterers of any age should be able to change readily from formal (in this sense based on a model) to informal letters, without any feeling of defensiveness. A lot will depend on the attitude of the teacher.

One of the surprising aspects of teaching young children is that they can sometimes produce startlingly original letters, intermingled with classical forms, the original versions of which they have probably never even seen. Their work can often bear comparison with trained 'professionals'. As a result of working with children and witnessing their amazing facility with letterforms, I sometimes wonder whether formal training, except in a few cases, does more to suppress originality than to encourage it!

49

How different tools affect letters

There is a huge range of pens and brushes to choose from, but remember that your choice will affect the letters that result. Sometimes the effect will be quite subtle, sometimes drastic, but sometimes quite miraculous. The stiffer the writing tool, such as a broad-edged pen, the more it will control your hand movements, and unless you go to extremes of thickness or thinness the appearance of your letters may remain conventional at first. The more flexible the tool, for example a softish brush, the more you will need to control it. A brush reacts to the slightest change in pressure and direction, so the resulting letters may have highly personal and original features.

Why stop at pens and brushes? Sticks, stalks, seed heads, leaves, feathers and almost anything you can pick up in the garden, on the seashore or from the waste-paper basket can serve as a writing tool. Ink is the obvious choice for use in writing, but any kind of paint, dye or home-made brew, thick or thin, can also work, and may produce different effects. Do not be shy of rainbow shades or subtle gradations of colour. What you produce reflects how you feel at the time of writing a particular letter, word or saying. The more involved you are, the more likely it is that the tool you choose and the way you use it will reproduce your feelings.

A screw-top jar lid 'printed out' thin letters, but with interesting results.

Scraps of torn paper pasted down to form letters could make a striking poster, perhaps for a jumble sale.

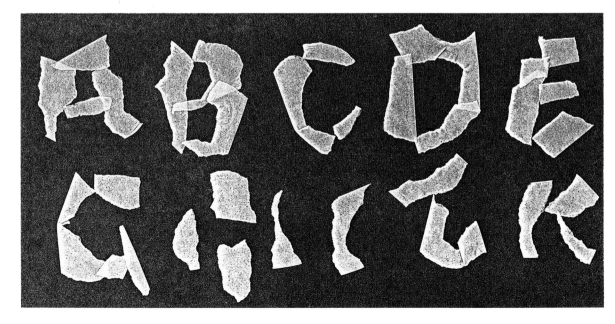

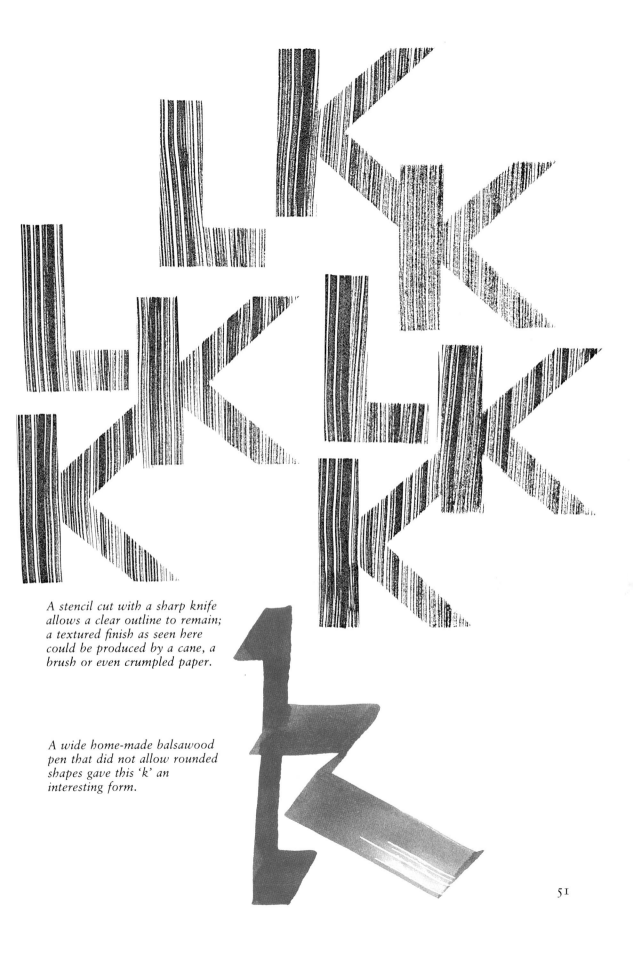

A stencil cut with a sharp knife
allows a clear outline to remain;
a textured finish as seen here
could be produced by a cane, a
brush or even crumpled paper.

A wide home-made balsawood
pen that did not allow rounded
shapes gave this 'k' an
interesting form.

How appearances can suggest meaning

The texture or proportions of the letters can suggest the meaning of a word in quite dramatic ways.

'Glue' was painted in pale-green watercolour, while 'Scratch' was written with a sharp scratchy pen and thickened up, although it looks as if it had been done on scraperboard and reversed. The word 'square' was freely written (about twice the size shown here) using a brush. The letters had not been drawn in outline first. You can often produce more interesting results by letting the tool influence the shape and character of the letters, as well as the spaces between them. The resulting effects are quite different from what you would achieve by carefully drawing an outline with a pencil and then filling it in. Sometimes everything will look right first time, but professionals who use similar techniques know that several attempts are often needed. 'Stain' was painted on damp absorbent paper, while 'fog' was produced by blowing wet paint through a straw. 'Dust' is the work of Charles, whose personal typeface appears on pp. 64–65. He had been cutting some letters on cuttle bone, using an old set of dental tools. He grated a piece of cuttle bone and then, after writing 'dust' in thick ink, using a fat brush, sprinkled the powder over it while the surface was still tacky.

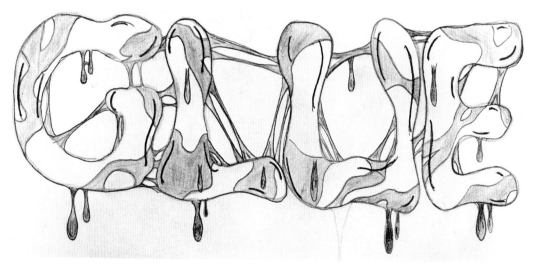

The expressive realism of 'glue', by eleven-year-old John-Mark Zywko, won him first prize in a competition organized by the Castle Museum, Norwich.

Painted on wet absorbent paper.

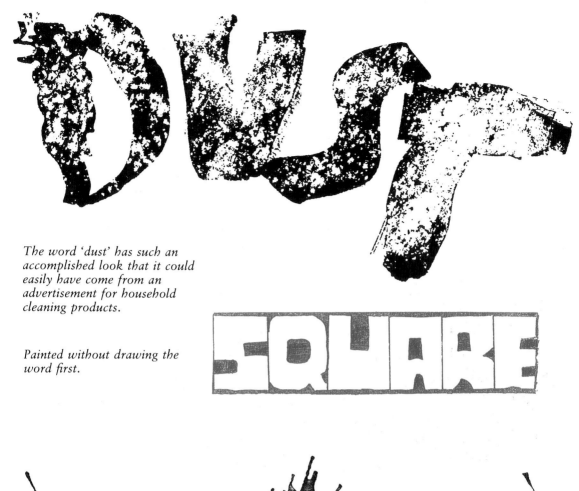

The word 'dust' has such an accomplished look that it could easily have come from an advertisement for household cleaning products.

Painted without drawing the word first.

Paint blown through a straw: these three letters were selected from a complete alphabet.

Written with a thin scratchy pen.

Unusual materials for calligraphic drawing

Many unconventional tools – sticks, stems, feathers or leaves – can be used for writing, and you can draw with them too. This picture, entitled 'Whaling in the old days', was a quick experiment using dried seaweed as a medium. It was done by a teacher looking for new ideas to use in the classroom. A beach is an ideal place for finding unusual materials for writing and drawing – but there are plenty of suitable 'writing' materials to be found in any garden or hedgerow, or in the household waste-paper bin.

These tree drawings result from the relaxed use of leaves and spattering. They can stand alone as pictures, or would combine well with free lettering.

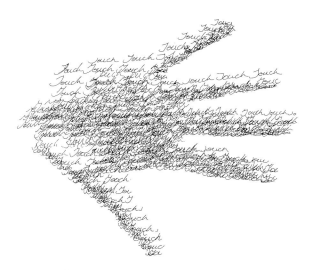
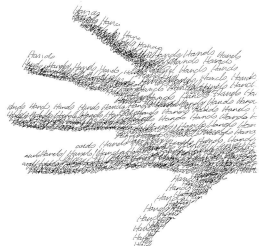

Using handwriting as texture

The letters that you are happiest with, and most consistent in, are evident in your own handwriting. Once you realize the letters can be put to use, it is only a matter of gaining confidence, relaxing and experimenting to find effective ways of exploiting them. The two illustrations on this page, by first-year art students at Curtin University, Perth, Western Australia, were just such experiments. The wave makes use of simple capital letters, but in the pair of hands the words 'Touch' and 'Hands' are written out. Both examples feature variations in size and spacing to control the density of the shading within the chosen shape. Another impressive example of this technique is reproduced on p. 40 and other work done in more formal calligraphic writing by schoolchildren is shown on p. 83. The more characterful your own handwriting is, the more effective it will be when used in this way.

Letters as pattern

This is an excellent way of producing greetings cards or decorating gift-wrappings. There are endless possibilities, and once you start to think about them you will invent your own ideas. A simple way to begin is to cut out a letter and use it as a stencil (see p. 21). These letters shown here were first written with a double pencil. The best one was cut out, then colour and texture applied through it. These are in no sense 'expert' letters. They were produced by students who had only been introduced to lettering the day before.

The more unusual a letterform is, the more interesting it may appear when repeated, so be prepared to experiment. If there is no photocopier available, you can cut up a few 'roughs' to experiment with layouts, then take your preferred version and trace over it on thin paper before pasting down the final repeated design. It is only a matter of scale. The larger the size, and the freer the form, the more striking the effect may be.

Repetition of the stencilled letter 'f' shown above creates a fan-shaped pattern; this is one of many possible ways of repeating a single letter for decorative purposes.

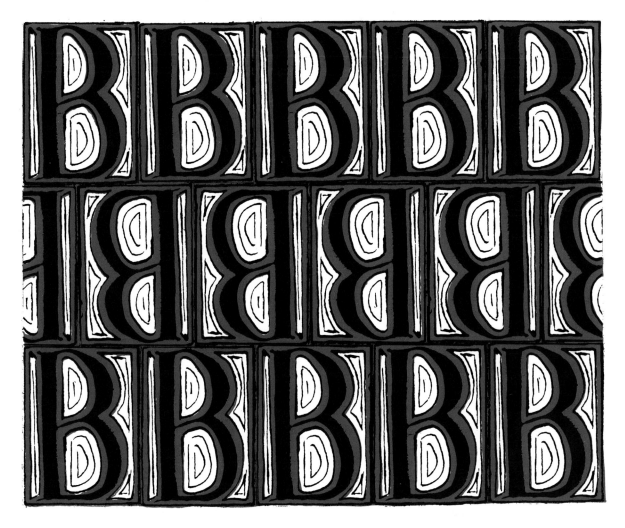

The drawing of the letter 'B' is not very expert, as is evident if you inspect it closely. This was a first attempt at a freely drawn, decorated capital. However, after being photocopied and repeated several times in different arrangements, it gained strength and began to look interesting as a composition.

The same is true of the letter 'g' shown opposite and repeated here as an overlapping pattern.

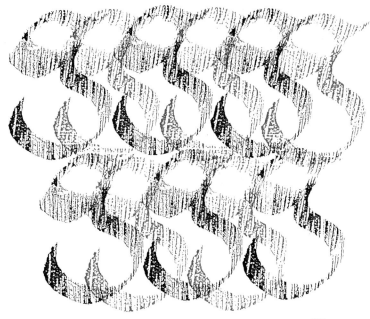

Monograms

Linking together your own initials – or any other small group of letters – to make a monogram is more than just fun. It is good exercise in combining letters to make a satisfactory design. You can use any style, formal or informal. The individual letters can remain separate, touch each other or be interwoven.

Once you have designed a single monogram, you can use it as the basis for a repeating pattern.

The letters 'MFK' formed the basic monogram, but 'MF' alone made a strong and effective band when repeated.

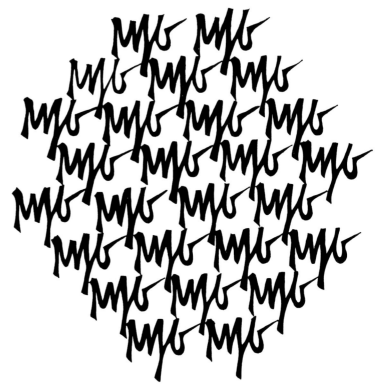

Examples of repetition used to form a continuous pattern.

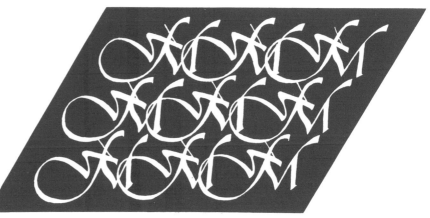

'DHL' started out in a simple form, but ended up looking completely different, with the basic pattern transformed into a delicate pattern of mirror images.

These initials were sketched (top) and reworked by Tracey Boughey, one of the many talented design students at Curtin University of Technology, Perth, Western Australia, whose work has made such an important contribution to this book.

Making a repeat pattern from a monogram

Monograms can be built up into complex blocks of pattern, which can then be repeated with the aid of a photocopier to cover quite large expanses of paper.

The photocopier or, if available, the computer can take the toil out of repeating smaller units. The design can be enlarged with no trouble at all, so producing a quite different effect. These two examples, by Rosemary Barrett, based on her initials 'RJEB', were both designed and repeated with the aid of a computer.

Left-handed writing

A B

H I

F P

R S

Some left-handers find it difficult to maintain the 30–45° angle needed to write the various classical alphabets: however, this problem does not arise when designing free letters. These examples show how two left-handed art students on a beginners' course in lettering produced their own letterforms, using pens or double pencils that were held at the angle which suited them best.

Nicole Grant started out by writing her monogram with the pen held in such a way that the down-strokes were the broadest and the cross-strokes the thinnest. She liked the look of the two thick lines separated by a narrow strip of white space, and quickly worked out a whole alphabet design. Some letters which were successful are shown here, while others, not surprisingly, needed more work. Designing a complete set of formal letters presents all kinds of problems. In this case the straight strokes were easy, but diagonal strokes, and some rounded ones, proved more difficult.

Felicity Fitzgerald, while breaking with convention by allowing thick lines to cross each other, succeeded in varying the presentation of her letters to produce an unusual repeating pattern, as shown above.

Brush lettering

Letters written with a brush can produce extremely effective results, but do not expect to achieve your ideal first time. Experiment and concentrate on the mood you want to express. Make several attempts at each word and choose the version that you feel is best. If half of one word 'works' in one version and half of another, cut them up and combine the parts you prefer. Professional designers rearrange their free letters in this way; they also make use of photocopiers for enlarging, reducing and repeating their work as necessary.

There are no fixed rules for brush lettering, but it is important to remember that the result should be legible. Some of the words illustrated were produced by young children and some by art students, but they all convey direct graphic messages.

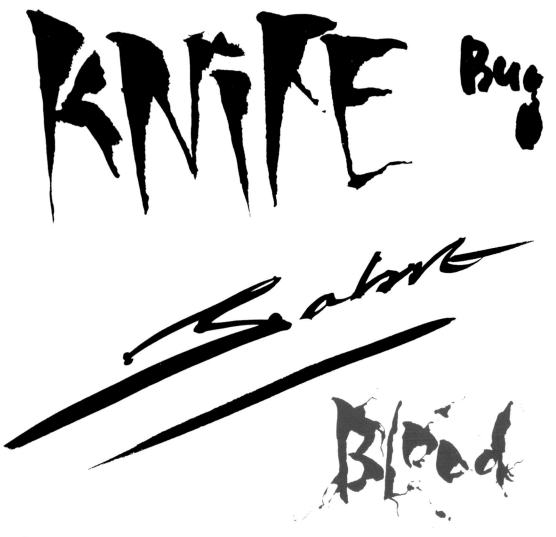

ABCDEFGHIJKLMNOPQRSTUVW
XYZ

JOG QUIZ

ABCDEFGHIJKLM
NOPQRSTUVWX
YZ

JOG QUIZ

abcdefghijkl
mnopqrstuvwxyz

jog quiz

*Two words made up from
individual letters in the alphabet
shown above.*

Brush
alphabets

Here are three examples of alphabets written quickly
by an art student. They have another practical use.
When you have just scribbled some letters as an
experiment, you can isolate the elements that are
most interesting within your personal hand. Start by
scanning the first set of capital letters: here 'G', 'J',
'Q' and 'U' stand out as having unusual features. The
same letters remain just as characterful in all three
sets, underlining the writer's consistency. With these
letters as a guide, it would be quite easy to build up
a complete improved alphabet. You need to find the
strokes and shapes that characterize the best letters,
and use them to improve the less interesting ones.

63

Designing an alphabet

Charles, aged ten, joined a mixed-ability adult group for a weekend of lettering. The workshop was held in Esperance, Western Australia – an isolated spot. Charles's home was a farm some 50 miles (80 km) from Esperance, but his parents made light of the transport problems, and in the circumstances it was lucky for him that he had joined the more orderly weekend course for adults rather than the weektime one for children. The courses are intended to provide greater opportunities for people of all ages to experience the satisfaction of designing letters.

Charles was not very interested in formal penmanship. He came alive once he started on free lettering. As soon as he began working with a broad-edged felt-tip pen, his assurance, consistency and the originality of his letterforms became apparent. He wrote out several alphabets, plus a few extra examples of any letters that did not meet with his approval – all with no outside help. He drew a grid and pasted up the set that he liked best. His businesslike way of measuring up his lines and tackling the job showed that he was a born craftsman.

The next step was to photocopy the alphabet and experiment with 'typesetting'. In this way Charles produced his own letterheading with the name (shown below) of a pottery that his father was planning to set up at the family farm.

Charles had crumpled up the rest of his work and thrown it away – but part of a teacher's job is to recover minor masterpieces from the waste-paper basket. I have assembled another alphabet from the letters that were rescued, as well as showing some of the reserves (left) to illustrate the variety of forms that Charles produced in a short time.

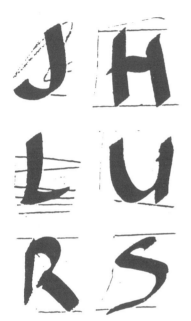

Some of the practice letters that were rescued after being discarded (above) and the letterheading (below) pasted up by Charles Creighton using the versions of letters he had personally chosen from his own alphabet.

CONDINGUP
POTTERY

A B C D E

F G H I J

K L M N O

P Q R S T

U V W X Y

Z

KEY

FOX

*A complete alphabet made up
from letters discarded by
Charles, and two simple words
(right) utilizing sample letters
from the alphabet.*

Designing a typeface
using a computer

Some of Maria's letterforms are quite unconventional. Look closely at her 'g' or 'q', or even at the way she writes an 'o' or an 'a'.

Maria Quiroz, a young Peruvian designer, used computer techniques to create a typeface based on her own handwriting. She said that one of her aims was to make computer output more spontaneous and 'human'. Maria also runs workshops with the aim of encouraging children to design computer-generated letters. Her approach to designing the typeface 'Antara' echoes my own ideas about using the consistency of your own natural movement and writing. It fits with what Charles found at a different level (see p. 64); his alphabet arose spontaneously from his own handwriting, unhampered by any preconceived ideas about formal letterforms. They fitted as a set because they were the result of natural movement enhanced only by the use of a broad-edged felt-tip pen. Undoubtedly he had a talent for lettering that was revealed through the original and successful letterforms that sprang from his pen.

Any type designer will tell you that creating a few original letters may be easy, but the problems arise in designing a complete set that fits naturally together. Maria, who was already well into the study of letter-design, found another problem: 'I drew some letters specifically for use as a source, but this was a mistake as they were too stiff.' We all know what can happen if we concentrate too hard and the resulting tension prevents us from writing naturally flowing letters. Maria found a good way round that problem by going back to an example of her everyday handwriting (left). She focused on certain details in her freely written letters and adopted them as a basis for her alphabet. They all fitted together quite happily because they were the natural and consistent trace of her own hand — even though some of her letterforms are quite unconventional. Of course, as a designer Maria already had a trained hand, and she could also work up the best of her letters, but that does not take away from the fact that the underlying principle was the same as the one evident in the ten-year-old Charles's original lettering.

Maria did not produce any sketches or drafts using pencil and paper. She created all the characters directly on the computer screen.

letter signs in Algebra). Letters
are not pictures or representations.
Picture writing and hieroglyphics
are not letters from our point of
view; and though our letters, our
signs for sounds, may be shown to
be derived from picture writing,
such derivation is so much of the
dim and distant past as to concern
us no longer. Letters are not
pictures or representations."

A sample passage set in Antara, a typeface designed by Maria Quiroz and based on her own handwriting.

From handwriting to the computer

Although each child in Maria Quiroz's class had only a short time on the computer, they put the experience to excellent use, and the letters they created were original and effective. They were told that they could do exactly what they wanted with letters. Unhampered by adult inhibitions, they were free to express their own ideas about the essence and identity of individual letters. Some produced just one letter, while others attempted a series. Put together as an alphabet, as Maria shows, it would not matter how varied the letters were. As sets they show ingenuity and lively insight into letterforms and as an initial or monogram they look remarkably accomplished. The work done by Maria's group shows that impressive results are well within the capabilities of schoolchildren aged nine. To do this they need to be stimulated, given access to suitable equipment and allowed to experiment.

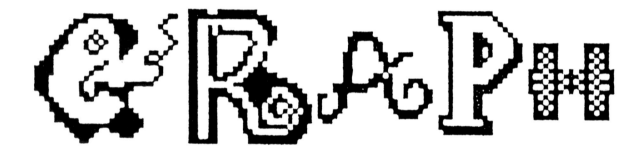

The work shown here was produced while Maria was an artist in residence at the exhibition 'The Spirit of the Letter' held by the Crafts Council in London. Groups of schoolchildren (and a few adults) were invited to experiment with computer-generated letters. Afterwards Maria said: 'Children approached the task in various ways. Some drew their letters as if they were writing on paper. Others constructed them as if they were using Lego blocks. All of them enjoyed it and were proud of the results that were printed out.'

The technicalities of computer graphics may vary from system to system. Maria used an Apple Macintosh, Fontastic Plus software and an Image Writer II. She hit upon a simple but ingenious idea to bridge the gap between this system and what young children could attain with or even without access to a computer screen. Her solution was born out of sheer desperation, as so many good ideas are. She had to run a workshop with a group of eighteen children and one computer, so while one was sitting at the keyboard the others had to be kept busy. She therefore introduced them to the simple principle of digitization.

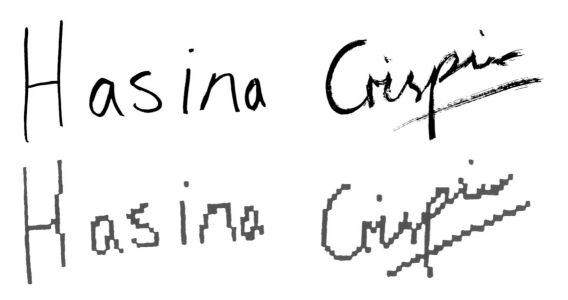

Maria gave each child a thick marker pen, to be used freely to write their own name. She then provided pieces of graph paper and showed the children how to translate their signature into an elementary bit-map on the squared background. The result was reduced on the photocopier, thereby simulating a computer exercise.

Teaching lettering in schools

Lettering should be re-introduced in all schools. At this learning stage the aim is not perfection, but the development of awareness and the encouragement of creativity, starting in the infant class, where the teacher requires no special training in lettering skills. All that is needed is an awareness of the infinite fascination of the subject. This is one area where the pupil will soon teach the teacher. Young children, before they are exposed to the plethora of printed material that we all encounter every day, can be inspired to produce their own ideas for letters and, given the chance, they will compare and discuss features of their own and other people's work.

Many professional letterers report that they first became aware of letterforms at a very early age, so a teacher of young children may help to spark an interest that will last a lifetime. At the age of five or six children can produce imaginative banners if each contributes an individual decorated letter, and I have also seen young children designing and sewing appliqué letters which resemble medieval illuminated initials. Collages involving letters, or printing by means of potato cuts, stencils and other simple techniques, appear on the walls of classrooms where teachers have no specialized knowledge of lettering.

A little later on, personal lettering by each child integrates well with project work. There are always deeper levels to be explored by any teacher or individual student. Whether handwritten informally or copied somewhat more formally, our letterforms are reflections of ourselves on paper. Letters dating from past centuries reveal many of the characteristics of these earlier periods and, combined with the changing usage of writing, this study has a fascination that children easily relate to.

At what stage lettering is studied in more detail is a matter for decision by individual schools. Staff with the necessary skills are surely increasing in numbers as calligraphy classes become more widespread in adult education. Examples of results achieved by all ages are shown in the pages that follow. Their attainments communicate far better than words the interest and satisfaction that they found in their work.

This 'Snake' by Philippa Matthews was her first and only attempt at lettering – an experiment she tried at the age of fourteen. It is a striking design in yellow, green and black, which I took to be an advanced piece of work when I first saw it at her home. I then discovered that Philippa attended the school where Peter Halliday teaches calligraphy (see p. 82).

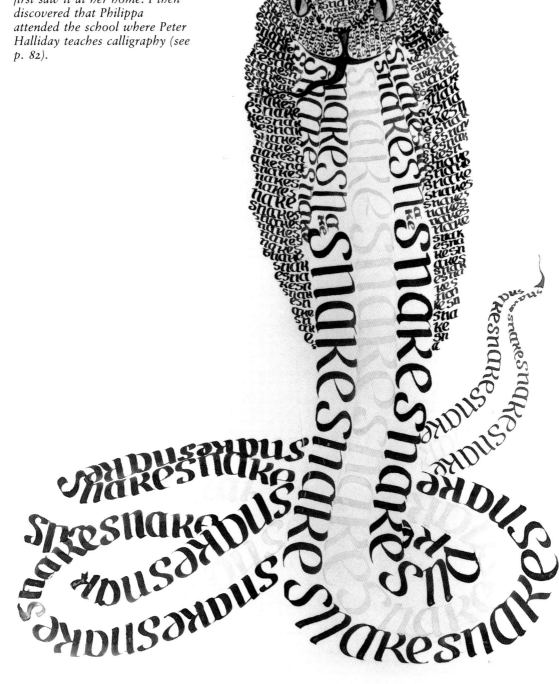

First stages in lettering

Every day children are exposed to many different letterforms, from high street advertising to television graphics, long before they begin learning to read and write. Once the formal learning process begins at school, they tend to concentrate on one particular letterform model, but experiments with other forms and uses of letters should be encouraged before young children become too inhibited by conventional attitudes. At this early stage – as we have already seen – a young person's creations can often stand comparison with professional work.

Children usually find it natural to write words like 'ice' or 'sun' in a style that suggests the meaning of the word, or they may design a wrapper for something they specially like to eat, done in such a way as to suggest the qualities which they find most delicious. This is a simple and amusing venture into what some typographers call the 'atmosphere values' of different letters. The teacher may need to provide help with the next stage, which might be to find letters appropriate for a particular historical period, perhaps as part of a classroom or individual project.

Freely written letters cut out of paper and card, used to illustrate project work by ten-year-olds.

Cut-out letters superimposed to produce variations of tone and texture.

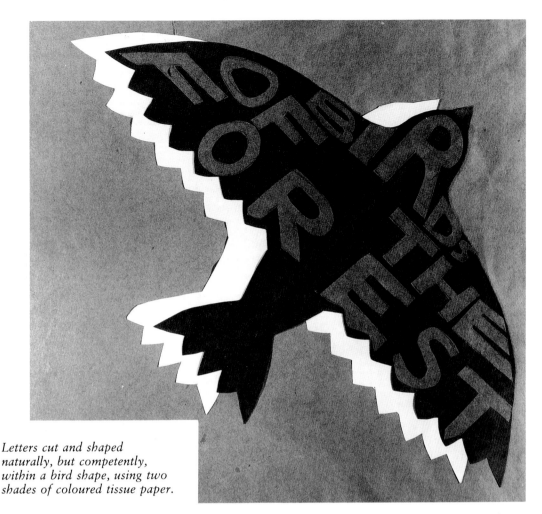

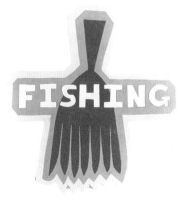

Letters cut and shaped naturally, but competently, within a bird shape, using two shades of coloured tissue paper.

The examples shown on these two pages are the work of children aged between nine and eleven at Amherst Junior School, Kent, where the importance of letters and layout has been stressed over many years. Their annual display of work included many examples of unusual uses and imaginative forms of lettering. Patricia Parsons, whose pupils provided many of the examples, has a strong personal commitment to art and design, promoting an awareness of letters throughout the school. By stressing sensitivity and appropriateness to any particular task, through form, texture, colour and technique, she encourages the children to take a pride in what can best be termed 'graphic presentation'. Those children who have benefited from this kind of enlightened approach are usually identifiable because their written work is laid out so well. This is just one of the possible advantages which a policy of introducing children to lettering at an early age can bring.

Bringing the alphabet to life

For children the history of letters, or indeed of writing itself, is a subject in which interest is easily aroused. Often it is the adults who are indifferent to letterforms, no longer seeing the fascination of something they have come to take for granted. In an attempt to remedy this lack of awareness, I gave some courses for teachers that aimed at involving schoolchildren up to the age of eleven in tool-making and practical work. This called for the study of letters and their usage throughout history, and consideration of their relevance and influence today, whether written or printed. The information gained could be linked to all kinds of project work.

This is how it worked out in the classroom. The basic natural writing materials used in antiquity, such as clay, chalk and charcoal, are still available; and other necessary historical reference material can usually be found in local libraries, museums or educational resource centres. A project like this calls for quite a lot of preparation. Schools might well spread the work over a whole term. My efforts, of necessity, were limited to single days and were organized to allow as many children as possible to take part. I usually worked with double classes – about fifty children at a time – aged from seven to nine.

The secret of successs has been to divide the children into groups, after a short introduction to this rather unusual way of participating in the history of writing. This meant that children could choose which period to study, and still be relatively free to change around as they wished. The subjects covered included:

1. Sumer and cuneiform;
2. Egypt and hieroglyphs;
3. Roman capitals and numerals;
4. The medieval scribe;
5. The invention of printing;
6. The Victorian classroom;
7. Looking at other writing systems;
8. Modern lettering.

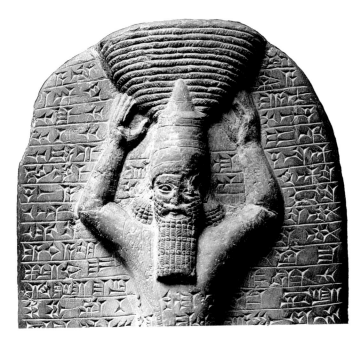

Ashurbanipal, king of Assyria, shown as a basket bearer, 668 BC.

1 Sumer and cuneiform

Ten-year-old Sophie Lovett's attempt at imitating cuneiform.

Interpretations of how Sumerian farmers could indicate five sheep and five goats by making impressions in soft clay.

Writing has its origins in and around Sumer in ancient Mesopotamia c. 3000 BC. The simple clay tablets that farmers in the fertile area between the rivers Tigris and Euphrates used to record their flocks on the way to market developed into more complex seals and tablets, and eventually into the intricate writing system known as cuneiform.

Modelling clay is available in most schools, though if there is a natural source locally, visiting it would add another interesting dimension to the study. Modelling tools can be used as an approximation of the stylus that was used to produce cuneiform's characteristic indentations. Given time, children can make a proper stylus for themselves.

The sun-dried clay tablets as used in Sumer survived the destruction of cities by fire – in fact the clay was baked even harder. Found and translated in relatively recent times, the surviving cuneiform writing includes school records and writing tablets. Today's children can therefore be made aware of what was taught in schools thousands of years ago. They might be surprised at how similar some of the lessons were.

2 Egypt and hieroglyphs

Few children can resist the attraction of hieroglyphs. It is possible to obtain books that show children how to write their names in hieroglyphic form. This is just one way of explaining the system. The teacher would have to decide how detailed a study to undertake, but there are many ideas that can be introduced here, such as the relationship between local materials and the development of a system of communication. The modern use of pictograms, such as road signs, provides a link with the past, and demonstrates how the use of easily recognizable symbols transcends language – an idea for yet another project.

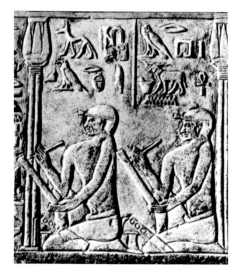

Military scribes, from an ancient Egyptian relief in the tomb of Horemheb at Saqqara, 14th century BC.

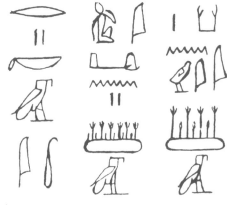

3 Roman capitals and numerals

We usually think first of Roman capitals in the context of inscriptions carved on stone. The exact form of many Roman letters provides a starting point for a discussion, as well as giving an opportunity to explain how the tool used affects the shape of the letters. This can lead logically to an explanation of the difference between capital letters, made up predominantly of straight strokes that are easy to cut, and small letters developed to 'run easily along the line'. Any lingering confusion can be cleared up by a practical demonstration of cutting simple letters into soft clay, wood or expanded polystyrene etc. If blocks of salt or chalk are available locally, these are even better, for they also link in with the idea that, historically, people used whatever natural materials were present nearby. The more durable the material, the more has survived until today for us to study and learn about the past.

Roman numerals can be a short project in themselves and, like the capital letters, can be cut into clay tablets to simulate stone-carved inscriptions, or burned or scratched into wood. Roman cursive

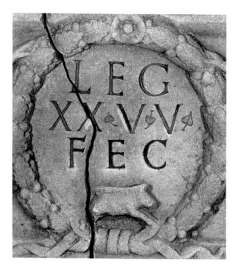

Incised Roman letters and numerals, 3rd century AD, *from a funerary monument.*

Examples of rustic Roman capitals and cursive script.

script shows how letters were gradually altered until a freely written alphabet evolved. Children may find it interesting to trace the origins of some of our own letters in the later Roman cursives, though they will probably need help in deciphering these scripts.

Because Britain was once part of the Roman Empire, there are many surviving remains in national and local museums and at important archaeological sites, such as Hadrian's Wall. Churchyards and any other localities where letters carved in stone are to be found make an interesting follow-up to this introduction. Gravestones can, with permission, be a source of rubbings that bring local history to life.

Graffiti, ancient and modern, might also be studied. There were examples of scribbling on the walls of Pompeii in the 1st century AD, as well as in our urban environment, though the practice is not to be encouraged.

4 The Medieval scribe

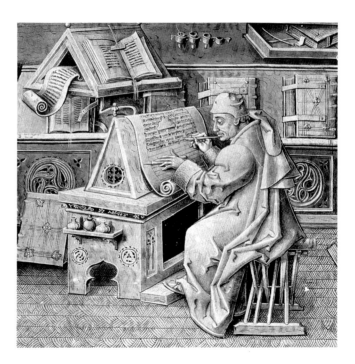

A 15th-century scribe at work copying from a manuscript.

It is relatively easy to recreate the idea of life in a monastic scriptorium – with or without dressing up. Feathers cut (or even uncut) to serve as quills provide ideal writing tools. One school found an old recipe and brewed up home-made ink in science classes. All kinds of carbonized material can be (and was) ground up for this purpose.

A 14th-century initial from the Carlisle Charter (below), and two recent examples of decorated initials by children attending Edenbridge Middle School, Kent.

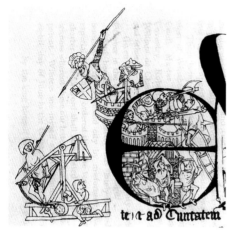

Most children enjoy copying illuminated initials and there are many examples to choose from. Apart from writing purely decorative initials, the medieval scribe would often include figures and scenes from contemporary life. The production of even one beautiful decorated initial letter, perhaps reflecting modern life, can provide real satisfaction. During my workshops I noticed that it was often the children described by their teachers as 'under-achievers' who had to be torn away from the 'scriptorium' at the end of a session. If encouraged at such sessions, children might well develop a lasting interest in calligraphy.

5 The invention of printing

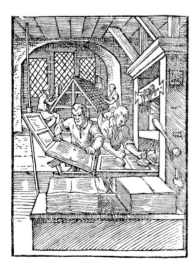

The interior of a 16th-century printing press, from an engraving published in 1568.

Here the emphasis is on the speed of printing and how its invention influenced the spread of books and education. You may use any form of printing, from potato-cuts or home-made stencils to movable letters.

You could extend this to modern techniques using photocopiers or scanning into computers where available. A visit to a printing press to see the production of a local newspaper at first hand is always a successful day out and any new knowledge can be applied to producing your own news-sheet on the school's word-processor. Then you can compare the time taken to set type and print a page with the preparation of one written by hand.

You might bring up the plight of the scribes, who lost their jobs. Maybe some of them adapted their skills to become the writing masters who took up work in private homes, and in the schools that began to develop rapidly with the advent of printing. This could be an opportunity for another group project. It might be interesting to set your children up as 16th-century writing masters.

6 The Victorian classroom

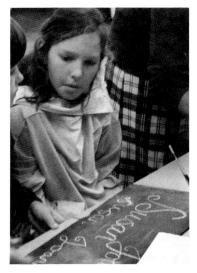

Working with chalk on slate.

write

A written word shows how a child paid close attention to the copperplate alphabet.

7 Looking at other writing systems

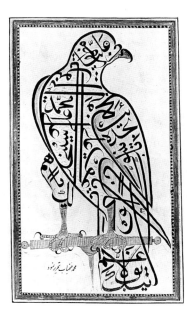

A lesson in 19th-century copperplate can be re-enacted with the aid of a few discarded roof slates or their equivalent, and some chalk for writing. The slow rhythmical, repetitive exercises that are needed to perfect the difficult letters bring home to children how the emphasis in the classroom has altered. We pay less attention to precision and perfection, and allow more time for creative work. It may surprise you, however, to discover how many students enjoy the discipline of copybook copperplate exercises.

Aim at improvement in every line.

An example taken from *The Universal Penman* engraved by George Bickham in 1743 is here compared with three lines from a child's copybook dated 1852.

Quarrelsome persons are dangerous
Quarrelsome persons are dangerous
Quarrelsome persons are dangerous

Chinese and Arabic signs are to be found in many cities, but what of personal handwriting? We live in a multicultural society and it is time that writing systems other than Latin were studied and valued. This is not only to discover the details of the letters, but to consider the place of writing in other cultures, where it often has a far higher profile than in our own. Any school that has students or teachers who use Arabic, Chinese, Greek, Hebrew or any other writing system is fortunate. Multicultural studies tend to focus on music or other facets of life, but neglect writing, a subject closely allied to history and to whole cultures which can be introduced as a topic for study. An example of a Muslim prayer, written within the outline of a falcon in the early nineteenth century, is shown on the left. Handwriting and attitudes to letters in general illustrate the rise and fall of civilizations, and mirror the educational and social priorities of a particular period. To study and replicate the letters of any particular era is truly to 'feel' history.

8 How designers use lettering today

In any of my sessions the members of this group take on the role of graphic designers, producing their own designs for packaging and advertising. Adults as well as children need to understand how people's attitudes can be manipulated. The letterforms, the colours and the way they are arranged, convey different impressions and suggest what an advertiser wants us to believe. Children quickly pick this up, and can use either a book of typefaces or letters from their own imagination to redesign a familiar label, wrapper or television title.

Paul, aged nine, produced the design shown above as the basis for a wrapper to accompany an imaginary 'Train' chocolate bar, making use of lettering skills learned at school.

In cases where all the categories described above had to be fitted into one day, there was little time for anything more than a brief glimpse at the possibilities they offered. Even so, the feedback showed that this method of bringing the alphabet to life had far-reaching effects on the staff, as well as on the children, in terms of their perception of letters. Even to someone unacquainted with all the individuals concerned, it was clear that the children supposedly with learning difficulties often became most engrossed in these practical historical activities. These practical sessions brought writing and history to life in a way that captured the interest of individuals who perhaps had not felt this immediacy before.

Part of a display of work done by children at Edenbridge Middle School during their day devoted to 'bringing the alphabet to life'. The local library and resource centre had provided books and other material, and careful preparation by Martin Garwood and members of the school staff helped to ensure that the day's activities would benefit not just those who participated, but the rest of the school as well.

Lettering and the teenager

The serious work of getting to grips with letterforms at school can begin when children reach the age of eleven or twelve. This is the time to stimulate informed curiosity, the time to teach the basics of visual discrimination. The art department is the usual, but not the only place for this to happen. The close interdependence of words and meaning, which can be reinforced by the use of appropriate letterforms and even the choice of a particular medium, relates to language and the teaching of English. In their turn poetry and prose may suggest a particular type of layout. In this way the subject of lettering can be introduced into many areas of the school curriculum.

A school may have a member of staff who is able and willing to run a calligraphy club. This might be a teacher of art or of English, or it could be supervised by a history teacher whose interest has come about through a knowledge of palaeography and the development of letters. Alternatively, the woodwork or metalwork teacher might have an interest in three-dimensional lettering. Increasingly, schools make use of opportunities to invite craftsmen to give short courses. Lettering should feature as an important subject for a designer in residence, alongside the more usual craft subjects of pottery or weaving.

Local specialists may be willing to share their particular interests, for example a session with an antiquarian bookseller or a signwriter may help in sparking off enthusiasm for beautiful letters. Calligraphy is by no means the whole story, and the approach to the subject should not be limited to something so close to handwriting that some students are deterred. Just as certain children are attracted to one or other musical instrument, those who have an instinctive feel for letterforms seem to appreciate the scale and dimension of the letters that attract them. Students should therefore be introduced to a wide variety of letters and their usage, so that potential cutters and carvers of letters are attracted, as well as potential graphic designers and would-be typographers, and not just those whose main interest may always be in careful handwritten calligraphic forms. As the situations described show, a study of letters can range from an examination subject to a class project or a creative outlet for those with physical or educational problems.

Teaching calligraphy to teenagers

Peter Halliday is a past
Chairman of the Society of
Scribes and Illuminators. As
head of the art department at
the John Taylor High School in
Staffordshire, he is one of the
few professional teachers of
calligraphy at secondary level
who approach the subject in a
systematic way, not only to
provide a source of pleasure for
his students but as an integral
part of their art education and
as a subject for examination.

Do teenagers like the idea of learning calligraphy? In
Peter Halliday's experience they find it both exciting
and challenging – the extra dimension of 'the words'
seems to open up avenues which allow their emotions
and thoughts to come together. For him teaching
calligraphy to students aged from fourteen to eighteen
has always been an integral part of their broader
education in art and design. It has never been a
restricting factor; indeed, many who have opted to
try calligraphy because they consider that they lack
the ability to draw have found that the practice of
the discipline has unlocked a latent ability in art and
design, and some have gone forward to take up
careers in art.

On the face of it, the discipline involved in
calligraphy might seem daunting, says Peter Halliday,
but the fascination of actually making letters, seeing
them flow from the pen, soon overcomes any
thoughts that calligraphy is 'too hard' or takes too
long. However, he has found it important to
remember that it is the freedom that the pen can give,
rather than the discipline required, which needs to be
emphasized.

After an initial period of trying out a dip pen, his
students are introduced to the restrictions and
structure of the alphabet and to calligraphic style,
and they practise going through the alphabet letter by
letter. Once the letter structures have been learned,
though not yet perfected, he introduces the concept of
conveying ideas using calligraphic form, so producing
'calligrams'. These word pictures introduce aspects
such as legibility, distortion, spacing and control of
colour. It is usually at this stage that any students
who wish to turn to other disciplines choose to do
so. Imagination and a degree of interpretation are
involved in producing simplified and formalized
images with wording that relates to the chosen
theme. Two examples, 'Portrait' and 'Fire', are
illustrated on the page opposite. They were done
after three two-hour practice sessions at weekly
intervals.

What follows is a steady advance through aspects
of layout and design, the learning of different hands
and an introduction to wider uses of calligraphy and
lettering. Many examples of work by famous lettering
artists are studied and emulation of these is
encouraged. Experimenting is also encouraged, with

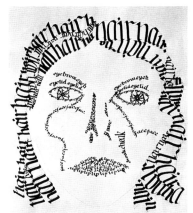

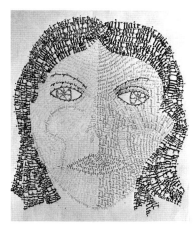

Two versions of 'Portrait' by Sophie Smith.

Varied tonalities and curves suggest the flame of Velma Hill's 'Fire'.

the emphasis not on the idea that 'you can't do this', but on 'see if you can make it work'.

From the age of sixteen onwards Peter Halliday's students may specialize in calligraphy and lettering, but still within the broader context of art and design education. The drawing *and* writing of Roman capitals are then studied in detail. An understanding of Roman capitals and their relationship to type design is of fundamental importance in the development of the subject and in gaining an understanding of historical development. Much of the work done by students during this stage is based on extending their own perception of their work and on research into the historical background of written and printed communication.

hist whist
little ghostthings
tip-toes
twinkle-toes

little twitchy
witches and tingling
goblins
hob-a-nob hob-a-nob

little hoppy happy
toad in tweeds
tweeds
little itchy mouses

with scuttling
eyes rustle and run and
hidehidehide
whisk

whisk look out for the old woman
with the wart on her nose
what she'll do to yer
nobody knows

for she knows the devil ouch
the devil ouch
the devil
ach the great

green
dancing
devil
devil
devil
devil

WheeEEE

e.e. cummings
written out by Madeline Hill

But what about
The people not having fun?
The boxer challenging
Man after man
The same act
Put on
Time after time
Does he ever get tired?
The man in the ticket box
Behind his smile
The same old smile
Does he tire?
The fortune teller
Dressed in the same clothes
The gypsey clothes
Time after time
Telling
Fortune after fortune
Does she run out of fortunes?

written out by Sharon Illsley.
April 1982.

For 'But what about...' Sharon
Illesley wrote the words with
round-hand pens, using Chinese
ink on cream-coloured paper.
The initial was painted in
designer's colour.

Opposite
Hazel Wilson wrote the text of
'maggie and milly and molly
and may' using round-hand
pens and white designer's colour
on a watercolour background
based on studies and
experiments in imitating the
iridescent mother-of-pearl effect
seen in certain seashells.

As a follow-up to the calligram, students are
given the opportunity to choose a literary text to
write out and decorate as desired. This exercise can
be seen as an extension of their work in drawing and
painting. Some of the students prefer to use their own
poems or prose. The two examples illustrated were
undertaken about six months after the students were
first introduced to calligraphy and after six weekly
sessions in which they would have developed and
refined their work, introducing colour and variation
in the size of the writing and experimenting with
different papers, some of them coloured. As part of
the design process, the steady improvement of
letterforms by individual students is important in the
overall development of skills.

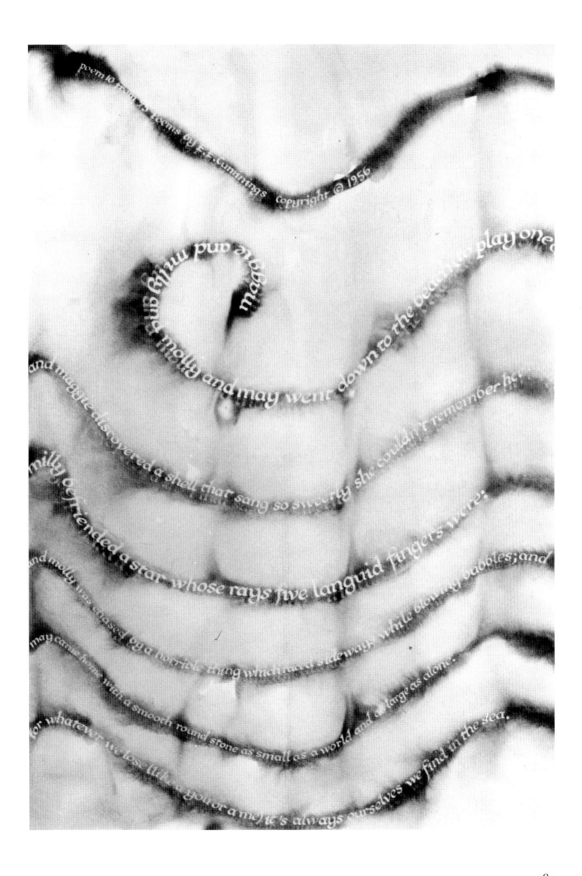

poem to rain / poems by E.E.cummings copyright © 1956

maggie and milly and molly and may went down to the beach (to play one day)

and maggie discovered a shell that sang so sweetly she couldn't remember her

milly befriended a stranded star whose rays five languid fingers were:

and molly was chased by a horrible thing which raced sideways while blowing bubbles; and

may came home with a smooth round stone as small as a world and as large as alone.

for whatever we lose (like a you or a me) it's always ourselves we find in the sea.

Projects on subjects chosen by students in the second year of their art and design course.

'Balloons' (detail) by Tracy Allanson and 'Ian Botham' by Alison Ravenhall, both of whom used round-hand pens, Chinese ink, watercolour and gold leaf on hand-made paper.

For 'In the beginning' Joanne Upton wrote the text with round-hand pens and Chinese ink, combining her choice of words with the use of raised and burnished gold and watercolour, all on hand-made paper.

Students of art and design who continue for two years after the age of sixteen are encouraged to undertake a major project during their second year. Such projects could be spread over a period of three or four months alongside other aspects of their course. Each student must research the chosen subject and compose the text to be incorporated. The illustrative element has to be collated and organized, and the overall design will be developed in a series of paste-ups before a final version is achieved. On completing their projects, students should feel fully confident in the use of any of the major calligraphic letterforms which, combined with their individual design skills, will enable them to organize even the most complex of arrangements.

A lettering workshop

Some of the letters from a complete alphabet produced by a class of eight-year-olds as individual characters on a standard grid showing x-height and the heights of ascenders and descenders.

Phil Baines is a graphic designer who is mainly concerned with typography. His first experience of teaching children was a three-day lettering workshop for eight-year-olds. This resulted in a composite 'type-face' for notices throughout their school. The preliminary exercises included making a collage using letters cut from newspapers and magazines. The next step was to make the children aware of form, weight and proportion. At the end of the first day the children each painted a single letter of their own choice. They then progressed through exercises introducing the details of the shape of letters and the factors that influence legibility. This stage included looking at the way we obtain most of our information from the tops of letters, and led to an understanding of the minimum amount of a letter that is required for recognition. This is an imaginative introduction to lettering and could have considerable influence on how children view their own handwriting.

For the main project the children were given a grid, setting x-height and ascender and descender heights (see examples on pp. 30–39). Although this was quite a disciplined exercise, it still produced some lively and interesting results which, when combined, were used for notices throughout the school.

The teachers planned to build on the work done in these three days. Their suggestions included

designing a school logo, a letterheading or a book-jacket. More ambitious projects included casting initials in plaster and designing an alphabet that could either be used in the smallest possible size, or large enough to be easily legible at a distance of 10 metres (30 ft). A follow-up to the second project turned into a legibility survey: first the 'designers' had to answer questions about the legibility of their letters, and then they had to decide how they could prove the success of the alphabet's final design. The testing would introduce such factors as: how many people constitute a fair sample in a survey; how many words to use; how to score the test; and finally, what other variables might affect the score. The children would also have to consider such matters as how to set about designing the letters, i.e. starting with a large size and reducing it or *vice versa*, and whether the colour or the medium employed would make a difference.

Notices within the school composed of separate letters from the children's alphabet included posting the names of teachers above their classroom doors.

Between Phil Baines' approach as a designer and the teachers' ideas for following up the ideas introduced in his course, a good balance was reached. Some tasks focused narrowly on the discrimination and discipline of a letterer and others were broadened to include observations in real-life situations and simple research projects. This is yet another route to discovering letters; one which extends beyond art or craft to reach a wider group of children, and leads them to an understanding of the implications of letters and lettering.

Lettering as therapy

Andrew N
ANDREW

XMAS

XMAS

XMAS

Andrew produced this Christmas card, and his unusual letterforms added to the interesting effect.

Kosta commented that in the past no-one had ever praised his handwriting. However, the freely written signature he produced in class worked out so well that he went off to have it printed on a T-shirt. (The example he took was heavier than this one.)

Lettering is not a skill only for those consciously seeking a creative outlet, nor should its execution be confined to perfectionists. It can have distinct therapeutic value in the rehabilitation of offenders sent to prison or in helping psychiatric patients. The act of lettering alone tends to produce a calming effect, in addition to the personal satisfaction and resulting increase in self-confidence that may be achieved. In some cases it helps in overcoming handwriting problems.

I spent a morning with a group of teenagers with special needs at Underdale School in South Australia. Andrew and Kosta were two of them, and their teacher, Howard MacPherson, explained how the session had helped them. Andrew, who as a result of injuries in an accident was experiencing learning difficulties, had already been given help with his handwriting, but he had not had a chance to try working on his own, using various implements and being allowed to write at various speeds and in various sizes, in a situation where he could forget about neatness or form and certainly about content. Kosta, said his teacher, 'would grind his pen into the paper, transforming the page into a sea of crests and troughs, clotted with ink. On turning the page, one could feel the Braille-like imprint of his letters. He also wrote painfully slowly.' There are no such indications in his free lettering, and when I met Howard MacPherson by chance a year later, the news of the boys' progress was most encouraging.

There was little chance of producing finished work during my session at Underdale, with some thirty pupils and only a couple of hours available – just enough to realize what the possibilities were. So it was a great pleasure to meet David Holgate, to hear him speak with obvious feeling about the workshops that he had held for teenagers with problems and to see examples of the work they had produced.

Helping handicapped students

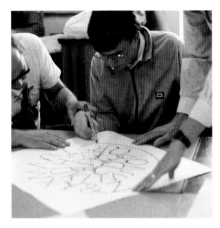

This boy was recovering from a serious accident, and the circular alphabet he produced represented a triumph for him in view of his limited movements. The work was rotated to help him manage the large letters.

The students in the special needs unit taking part in David Holgate's three-day workshop at St Vincent Sixth Form College, Gosport, Portsmouth, were all aged sixteen or over and suffered from various handicaps, ranging from a slowness in learning to physical brain damage. He writes, 'I was very concerned to develop a learning process that would have relevance to each individual student, taking into account the differing needs and forms of handicap. The approach would need to be a broad one. In this situation a "linear" learning programme would be doomed to failure. After much thought I decided to implement an experiment that had long been in the back of my mind.

'We all know from observation of ourselves and others that the greatest obstacle to be overcome when performing a new, demanding task is fear. The only option is to continue applying oneself to the task until the fear subsides to a level that can be called involved concern. Being aware of one's special limitations amplifies the initial fear response, sometimes to the point where a straightforward task becomes unduly demanding, and an irrational fear results. Over the centuries an old folk-remedy used to counter this has been to impose a steady rhythm such as "Tote that barge" or "Lift that bale". Those who specialize in lettering are well aware that in its execution one must have a strong sense of rhythm in order to produce the balance of mark and space essential to an aesthetically satisfying piece of writing.

'I began by talking to the students about some of the wonderful and exciting moments in the development of writing. I firmly believe that, in teaching, it is crucial to communicate a sense of wonder about the subject being explored. A short "potted history" of Western writing from the earliest forms of communication through some of the major "inventions" always regenerates my own enthusiasm and in turn usually makes a young audience eager to "have a go".

'I also found myself talking about the crucial relevance of timing in music. The length of a note and the length of the spaces between notes is a major part of the creative act in music, just as the proportion and spacing of letters is so crucial to lettering. I could demonstrate this with the musical instruments I had brought with me and by playing

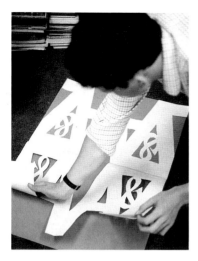

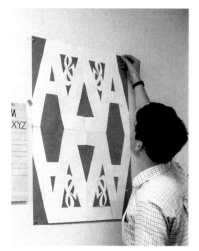

A cut-out design based on letters can be made with a mirror image by using a sheet of paper folded double. When opened out, the completed design can be pasted on to card of a contrasting colour for display. A series of alternating rows of letters (opposite) produced by a similar method and hung in front of a curtain lit from behind also makes a bold impact.

The strength and quality of the letters produced by the students reflects the degree of expert guidance offered by an experienced professional teacher such as David Holgate.

along with the beat produced by a drum machine. By drawing parallels between the visual "music" of lettering and aural music one can create a more stable vehicle of understanding.

'A practical task could now be undertaken: simple mark making to the accompaniment of a rhythm supplied by a disco beat already familiar to the students. A number of very positive points came to light.

1. There was a deep level of concentration in the task.
2. There was a strong atmosphere of *group* working – a concerted approach to the *same* task.
3. Very little distraction from the task. Normal classroom conversations and distractions were reduced to a minimum by the insistent rhythm.

The snags were:

1. After about an hour both the assisting staff and I found the background noise almost too much to bear.
2. Other staff in the college kept looking in to see what was happening and wanted to join in the activity.

'This approach could be seen as a gimmick, but the achievements of the students, some with considerable handicaps, belies this view. One young man who had suffered brain damage as a result of a road accident and who had been unable to write succeeded in writing, admittedly very large letters, on the second day of the project, to the great admiration of the other students. After expanding the possibilities of making marks to rhythm to a point where one could observe changes in the level of control, I felt the students should apply their developing skills and understanding to producing a finished piece of work, so the last day was spent designing and making an alphabet, each according to the character and personality of the individual. Some examples of the results are illustrated, showing how quickly even severely disadvantaged students can progress, given a high degree of stimulation and guidance.'

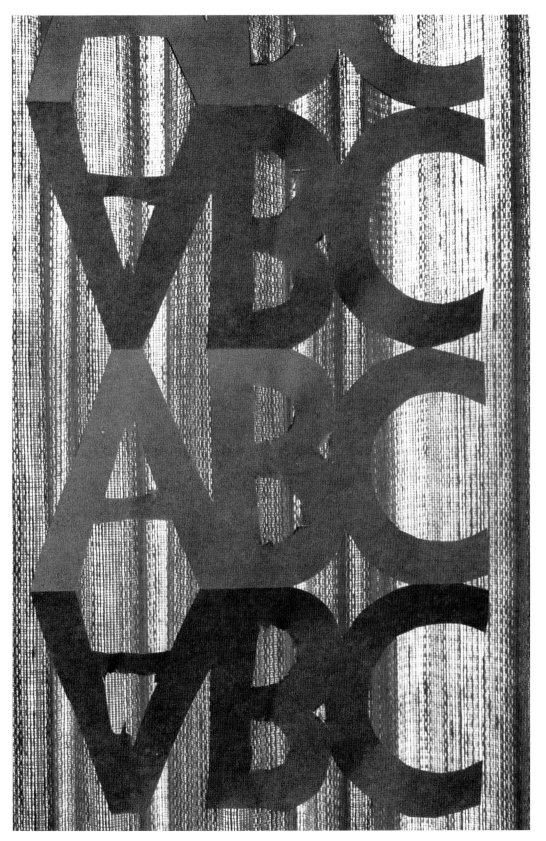

Lettering and the first-year art student

A fairly typical response to the brief, showing quite nicely drawn lettering and a good handling of the layout requirements.

Letters as fruit on a tree.

Fairly poorly drawn letters, combined with a well-handled layout based on the student's own design idea.

At a time when many art schools had abandoned any formal instruction in drawn lettering and calligraphy on the premise that such disciplines were no longer necessary due to the development of transfer letters and the many means of easy reproduction of typefaces, Derek Benny, who was for many years Head of Art at Ipswich School of Art, insisted on finding time in an already crowded syllabus for a continuing study of the classical Roman model. David Holgate was asked to visit the school for one day per week to instruct the students in the history of lettering styles in the belief that the knowledge they acquired would bring about a more informed handling of all lettering, in whatever form or medium. This was achieved by talking initially about the development of writing from its earliest forms up to the emergence of Roman capitals, and explaining the peculiar effects of history. The rediscovery of the Greek and Roman civilizations in the Renaissance era gave rise to a new interest in Roman letterforms, but led sometimes to a misinterpretation of the way in which the letters were formed, resulting in a dull, mathematical and geometric concept of the shapes and equally dull and insensitive methods of teaching. Perhaps surprisingly, these concepts and methods have persisted in Europe until our own time. The seminal book *The Origin of the Serif: Brush Writing & Roman Letters* (1968) by Edward Catich, with its scholarly exposition of the evidence for the brush as the creative lettering tool in Roman times, has changed all that, and the students were soon able to get on with the job of learning how to form letters using a chisel-edged brush, a technique demanding a great deal of practice.

Nicely understood Roman capitals in an altogether incongruous setting.

Although, in the limited time available, most students were unable to become proficient brush-letterers, they gained enough understanding to be able to undertake some fairly effective drawn Roman capitals that did not display the stultifying effect of the geometric approach. Five very typical responses to the brief 'Design an Alphabet using a classic Roman letter', an exercise undertaken about halfway through the students' first year, are illustrated here. It should be stressed that these are neither the best nor the worst examples from several hundred produced over a number of years, but they do show a marked degree of understanding of the 'fluidness' of a genuine Roman letter and that there is room for individual responses in the formation of a 'good' letter. Compare, for example, the several versions of 'R' or 'S' shown here.

David Holgate's experience is clear evidence that the practice of lettering is not only for the 'artistic' or for high achievers. It can range from an examination subject in art and design to a project which involves a whole class and it can also provide a satisfying creative outlet for those who suffer from physical or educational problems. Discovering and developing letterforms is therefore of value to all children and young people, regardless of their intellectual ability. They can enter into the spirit of the subject either as individuals or as members of a group, and their best efforts will probably be preserved with a sense of pride and achievement.

An overall pattern created by the constant repetition of a single idea: 'words'.